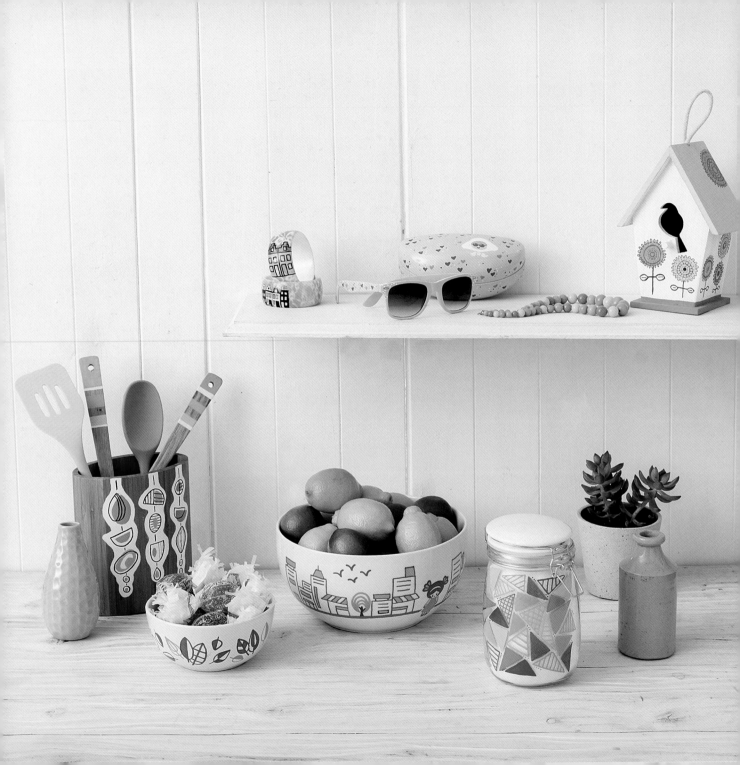

75 Original
Sharpie® Craft Projects to Design Your Home and Your Life

Deborah Green

WILLIAM MORROW
An Imprint of HarperCollins Publishers

HarperCollins books may be purchased for educational,
business, or sales promotional use. For information
please e-mail the Special Markets Department at
SPsales@harpercollins.com.

FIRST EDITION
Publisher: Kerry Enzor
Project Editors: Charlotte Frost and Lindsay Kaubi
Designed by Simon Goggin
Photography by Simon Pask

Library of Congress Cataloging-in-Publication Data
has been applied for.
ISBN 978-0-0624-3483-8

16 17 18 19 20
Printed in China by 1010 Printing International Ltd.
10 9 8 7 6 5 4 3 2 1

SHARPIE® and the SHARPIE® trade dress are registered
trademarks of Sanford, L.P. Sanford is not affiliated with, or a
sponsor of, this book. Sharpie markers are designed for art
use and are not designed or intended for FDA applications.
Please do not use Sharpie products on food or on areas of
objects or containers that come into contact with food or as
otherwise specified by Sharpie.

Ink permanence cannot be guaranteed.

Proper precautions should be taken when handling
glass or ceramics, which may crack or shatter during
heating or cooling processes. Take extra caution
when using flammable substances and always use
in a well-ventilated area and in accordance with the
manufacturer's instructions.

Contents

Key to Skill Level:

Beginner

Easy

Practiced

Intermediate

Advanced

Introduction

Some people might think that Sharpie markers are an office supply, something to mark the contents of a storage bin with, but this could not be further from the truth! In fact, they can be used to decorate anything from clothing and accessories to home décor, stationery, and even furniture.

Ever wanted to add an extra bit of color to your bookshelves or personalize your tote bag? Sharpie pens to the rescue! These simple tools—easily available at office supply stores—provide the perfect solution to your decorating needs. They are so easy to use that no matter your level of art skills you'll be able to add simple patterns and cute motifs to objects all around your home—and brighten up all kinds of accessories. You can even color in your sneakers.

The tools and techniques sections in this book provide a practical guide to using different types of markers and explain what kind of materials and supplies you can color with them. This section includes a guide to tips and tricks, such as how to get a watercolor effect, and how to prep and seal products for durability. You'll also learn how to transfer the designs from the book so you can work directly from a template if you prefer.

The designs and projects featured throughout the book are here to provide you with a wealth of ideas for stylish ways to make over everyday items. They will enable you to look around your home and discover opportunities to transform the things you already have with Sharpie art; or take you step-by-step through the process of creating fun and personalized handmade gifts for your loved ones. You can use the templates provided in this book just as they are or use them as a springboard to create your own Sharpie style!

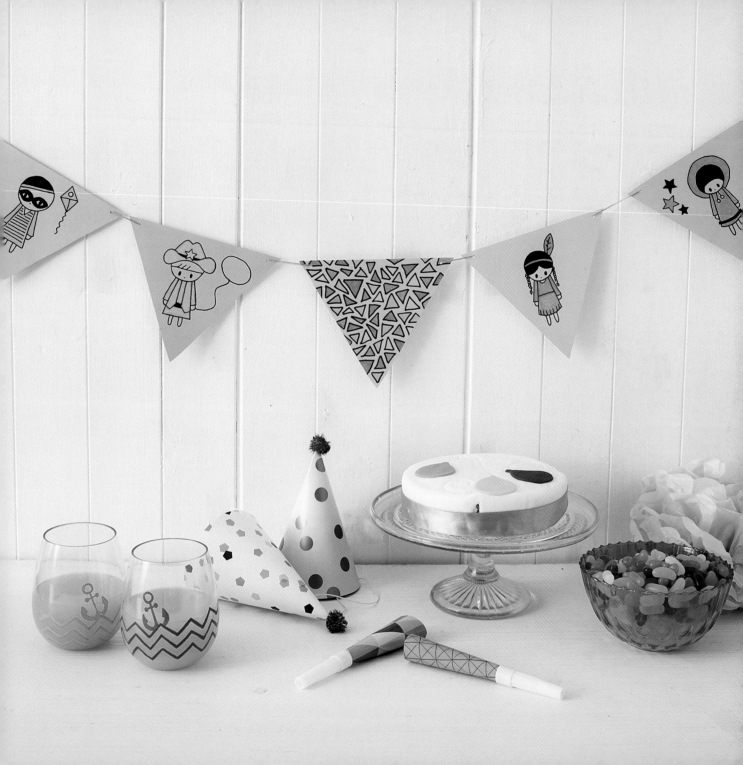

Tools and Materials: Markers

Sharpie makes many different types of permanent markers, highlighters, and pens. For the projects in this book you will need three different types of markers: The classic permanent markers, oil-based paint markers, and the "Stained by Sharpie" fabric markers.

Regular permanent markers

Regular thickness permanent markers are available in a rainbow of colors. They will usually leave permanent marks on most surfaces. However, they are not permanent on non-porous surfaces such as most plastics or ceramics. Permanent markers are great for working on paper; however, the ink can bleed through paper. To protect the drawing surface, e.g. other pages in a notebook, or the table you are working on, it's always a good idea to put some kind of protective layer, like a piece of cardboard, under the paper. Permanent markers are non-toxic, but can still give off a chemical odor, so be sure to work in a well-ventilated area. Unless otherwise stated, all permanent markers used in the projects in this book are the regular thickness.

Oil-based paint markers

Sharpie oil-based paint markers work beautifully on virtually any surface: ceramics, wood, glass, paper, plastic, and more. These markers have a durable and long-lasting effect. The paint produces a smooth opaque finish.

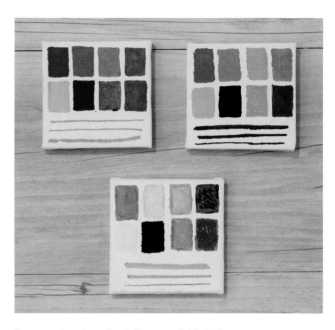

Permanent markers (top left) are available in the widest range of colors. Oil-based paint markers (top right) are the most pigmented and work well on all surfaces. Stained by Sharpie fabric markers (lower tile) have a variety of colors, including neon shades.

For the first use, press the tip once, then shake the pen, with the cap on, for about 10 seconds. Take the cap off and press the tip of the marker down four or five times on a piece of scrap paper to start the paint flowing. If the paint does not start to flow right away, repeat the shaking and dabbing until the paint starts to flow from the tip. Take care not to press the tip down for too long, or too much, as the paint will create a small puddle.

Keep your marker as vertical as possible while drawing to ensure the smoothest flow of ink. Not having an even flow of paint will result in uneven coverage and a streaked effect.

The ink in the oil-based paint markers is water resistant, so it isn't easy to correct mistakes. Keep a q-tip moistened with rubbing alcohol on hand when working with non-porous materials, such as ceramics and glass. If you act quickly enough, it will usually remove a mistake.

When using two or more colors of oil-based paint markers on one project, you will need to take care when the colors are worked over one another. Add a light coat of sealant (see page 12) before applying the second color to prevent the colors from mixing.

Safety first!

The oil-based paint markers are non-toxic, but they are not approved for food safety regulations. Don't use them on areas that may come into contact with food or your mouth (such as the rim of a cup). If you do use these markers on mugs, cups, or plates, keep the designs away from the rim, or any area where the food will be. Or just keep them for display only.

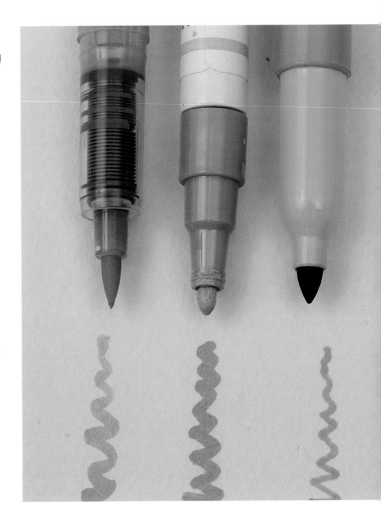

Left to right: Fabric markers have fine, brush-style tips designed for fabrics; oil-based paint markers have thicker tips which produce blockier lines; permanent markers have fine tips which are great for detailed drawings.

"Stained by Sharpie" fabric markers

Stained markers are specialty fabric markers. They come in bold colors, including neon yellow, orange, and pink. The ink is fade resistant, so finished projects can withstand a delicate wash cycle. They work really well on paper as well as fabric.

When using multiple colors on one project, wait for each color to dry completely before moving onto the next to prevent them from bleeding and mixing. Inks can also bleed through some types of fabric. To prevent this from happening, place a piece of cardboard underneath the fabric. When working on something like a T-shirt, slide the cardboard inside, so that the ink won't bleed through from the front to the back of the shirt.

Fabric markers have a long brush-style tip. For fine lines, use just the tip when drawing. For slightly broader strokes, gently push the marker down to use more of the side of the tip.

Choosing your pen

Sharpie produces a wide range of marker pens for a variety of surfaces and effects. Before beginning a project, always check that you have choosen the most suitable pen for your project.

Drying times

Be sure to let the ink on your projects dry fully before using them. Sharpie ink and paint drying times vary depending on the material that the base items are made of, and whether it is pourous or not. It is advisable to leave all items to dry for a minimum of one hour or ideally overnight before using them.

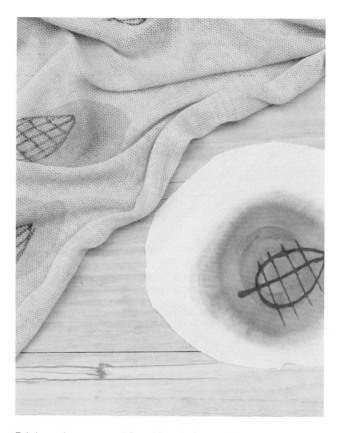

Fabric markers are great for adding designs to clothes and textile accessories. Alternatively, why not try using permanent markers and rubbing alcohol on fabrics for a watercolor effect (see page 13.)

Techniques

There are some general rules and techniques that apply to all or most of the projects in the book. Read through these pages before you start a project to ensure a great result.

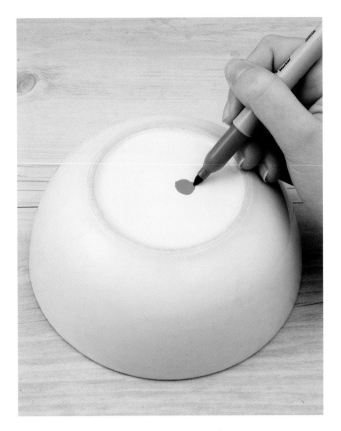

Test your marker on an inconspicuous area of your base item to help you choose the best marker type for each project.

For every project:

- **Start by cleaning the base item thoroughly**
 Make sure fabrics are washed and dried; rub and clean wooden items to ensure they are free from dust and grease; wash ceramics and plastics with soap and water, or rub them with a little rubbing alcohol or white vinegar.

- **Test your marker in an inconspicuous area of your base item before you start** This can be the bottom, the back, or the inside of the item to be drawn on. Make sure you have the correct type of marker for the project: For instance, permanent markers can work well on some sorts of faux leather, but depending on what type of finish the material has, the ink might not stick and you might need to use an oil-based paint marker instead.

- **Do a color test** Take the time to test how your chosen color comes out on your item. Different colored backgrounds can make the ink color appear different to what you expected. The appearance of any marker's shade will be affected by the color and material of the item drawn upon.

- **Be patient** Especially when working on non-porous materials. Allow time for the ink to dry. If the base material is glossy or slick, the ink can smear. Be conscious of where you place your hand while drawing, so as not to smudge the ink. Work slowly, giving the ink time to dry.

Sealants

For some projects you may want to use a sealant to protect the design. Varnish, clear acrylic spray, and Mod Podge® are all good options for this. Once all the drawing is done, let the finished project sit for at least 24 hours, letting the ink dry completely. Do a test of your sealant in an inconspicuous spot on the project first to check that it won't smudge the ink. What works best depends on what the base material of your project is, along with the type of marker used, so it's vital to do a test and, if necessary, try out different sealants.

Dried-up Sharpie markers

Maybe it has been a while since you've used your Sharpie markers, or one was left without its cap on by mistake. You might be able to revive a dried-up tip with the help of a little rubbing alcohol. Dip the dry tip of the marker in some rubbing alcohol for about a minute, until the tip is fully saturated. Put the cap back on, and leave it for 10–15 minutes. Test the marker to see if the ink flows through the tip again. If not, try the rubbing alcohol dip again. If there really is no more life left in your Sharpie, and you are located in the USA, you can donate your empty Sharpie markers to be recycled. The organization TerraCycle will provide a pre-paid shipping label for you to mail old markers to them. They will then either recycle or re-purpose the materials.

Graphite paper transfer technique

Graphite paper is an affordable, easy-to-use tool for transferring designs to any surface a pencil can write on. It works on materials such as fabrics, plastic, wood, glass, and ceramics. When you put pressure on the reverse side of the paper, it releases the graphite onto the surface, creating a copy of what is drawn.

How to use graphite paper

1 Draw the design on a piece of paper. Make sure that the image is at exactly the size that you need.

2 Cut out a piece of graphite paper the same size as the design sketch.

3 Lay the sketch on top of the graphite paper and gently tape both pieces of paper to the project item. Make sure the graphite side is face down toward the project.

4 Use a pencil to trace over the sketch firmly. Check the lines by gently lifting up a corner of the sketch and graphite paper but take care not to misalign the work. If you press too lightly the image won't transfer very well. If you press too hard, the transferred lines may be too dark but you can use an eraser to lighten them.

If you don't have any graphite paper, another option is to use the graphite from a pencil to transfer your design. Draw your sketch with a pencil, pressing firmly on the lines to ensure there is plenty of graphite to transfer. Tape the drawing onto the item, drawing facing inward, so the design is hidden. Transfer the drawing by firmly scribbling over the back of the paper. Remember, this will create a reversed image on the surface rather than a true copy.

Tip: You can reuse graphite paper a few times before the graphite wears out, so save the sheet and use it multiple times.

Watercolor effect technique

Adding some rubbing alcohol to the ink from regular permanent markers causes the ink to spread and thin, and creates a wonderful watercolor effect.

How to create a watercolor effect on fabric

1 Make sure the fabric is washed, dried, and ironed, and protect your work surface with a small sheet of plastic or a plastic bag. If you are working on a t-shirt, for example, put a piece of cardboard inside it to keep the ink from bleeding through to the back of the shirt.

2 Draw some rough areas of color with regular permanent markers; there is no need to be precise. Then, using a paintbrush dipped in rubbing alcohol, brush over the colored areas. Alternatively, using a medicine dropper or a saturated q-tip, add the rubbing alcohol to the center of each color and let it work its way outward, mixing with the color and spreading.

3 Add more color and/or rubbing alcohol as needed until you are happy with the design.

Heat-setting fabric technique

Once your fabric design is completely dry, secure the design by heat-setting it.

How to heat-set fabric

1 Use a low setting on your iron and no steam. Place a clean cloth over the fabric and iron on each side for 3–5 minutes.

2 If the fabric needs washing afterward, use a cold wash and lay it flat to dry.

Heat-setting ceramics technique

Cheaper ceramics work best, because these tend not to have a high quality glaze, meaning they are more porous and easier for the Sharpie ink to stick to.

How to heat-set ceramics

1 Clean the ceramic surface thoroughly with rubbing alcohol. Make sure to remove any labels, glue remnants, or stickers. Leave to dry and try not to touch the work surface too much.

2 Use oil-based paint markers to draw the design. Draw directly onto the item with the markers, or use the Graphite paper transfer technique (see page 12) to transfer the sketch first and then work over the lines. Take care not to smudge the design while drawing.

3 Leave to dry for at least 24 hours.

4 Place the ceramic item on a foil-covered baking tray in a cold oven. Turn the oven on to 400°F (205°C). Once the oven is heated and has reached 400°F (205°C), start a timer for 40 minutes.

5 After 40 minutes turn off the oven, leaving the item inside to cool off slowly. It's very important to allow the ceramics to gradually heat up and cool down in the oven so that they don't crack because of a sudden change in temperature.

6 Once cooled, take the item out of the oven and leave it for 24 hours before using.

Heat-setting glassware technique

Glass does not have the same glaze coating as ceramic, and can be heat-set at a lower temperature and for a shorter time.

How to heat-set glassware

1 Clean the glass surface thoroughly with rubbing alcohol. Make sure to remove any labels, glue remnants, or stickers. Leave to dry and try not to touch the work surface too much.

2 Use oil-based paint markers to draw the design. Draw directly onto the item with the markers, or use the Graphite paper transfer technique (see page 12) to transfer the sketch first and then work over the lines. Take care not to smudge the design while drawing.

3 Leave to dry for at least 24 hours.

4 Place the glass item on a foil-covered baking tray in a cold oven. Turn the oven onto 300°F (150°C). Once the oven is heated and has reached 300°F (150°C), start a timer for 20 minutes.

5 After 20 minutes turn off the oven, leaving the item inside to cool off slowly. It's very important to allow the glass to gradually heat up and cool down in the oven so that it doesn't crack because of a sudden change in temperature.

6 Once cooled, take the item out of the oven and leave it for 24 hours before using.

Colors changing after baking

Sometimes the colors of the paint markers change slightly after baking the finished pieces in the oven. Whether this will happen or not depends on a number of factors: the exact type of base material used; the amount of time the piece was in the hot oven; and the temperature of the oven. When baking, check the piece 10 minutes before the end time and see if the colors are starting to change. If they do, lower the temperature by 25–50 degrees. This may slow the process down just enough.

Safety first!

- Rubbing alcohol is very flammable and must be kept away from any open flames or heat. Only use rubbing alcohol in a well-ventilated area. Make sure the rubbing alcohol is thoroughly dry before heat-setting fabric.
- Check your ceramics and glassware for chips and cracks before placing them in the oven. A cracked dish can shatter in high temperatures, either inside the oven or on the countertop right after it is taken out of the oven.
- Baking the oil-based paints in the oven will give off a strong smell; make sure you ventilate the area by leaving a window open while baking. Do not bake plastic objects or any other object you are not certain will be unaffected by heat.

The saucer on the left shows the colors before they were baked in the oven. The saucer on the right shows the colors after they have been baked. Reds, purples, and oranges seem to be especially temperature sensitive. For the purposes of this example, the glass saucer has deliberately been baked longer and at a hotter temperature than required to set the ink.

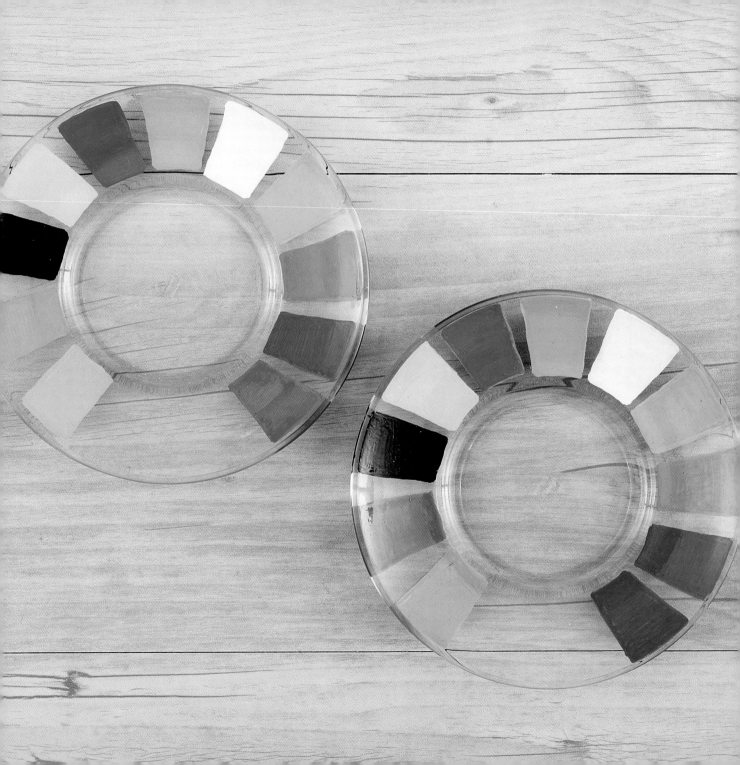

Mushroom Pencil Case

A freehand repeat of lots of little mushrooms makes for a simple but striking design for a pencil case. Choose colors that match your pencil case and play around with the position and size of the mushrooms.

1 Decide where you want to draw the first mushroom. To build the pattern, it is easiest to start off in one of the corners.

2 Using a dark color permanent marker, such as brown or black, draw the outline of a half circle or half oval. This will be the cap of the first mushroom.

3 Using the same dark color, add a mushroom stem beneath the cap. Again, draw a half circle or half oval. Just make it a little shorter and narrower than the mushroom cap.

4 Move over to draw the next mushroom. In the same way as before, outline another cap and stem.

5 Continue drawing mushroom outlines until the area is filled. Change their size and orientation to make the pattern more interesting.

6 Let the ink dry completely. Then fill the shapes with colored permanent markers. Using the white oil-based paint marker, add dots to some of the caps. Terrific toadstools!

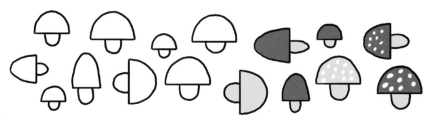

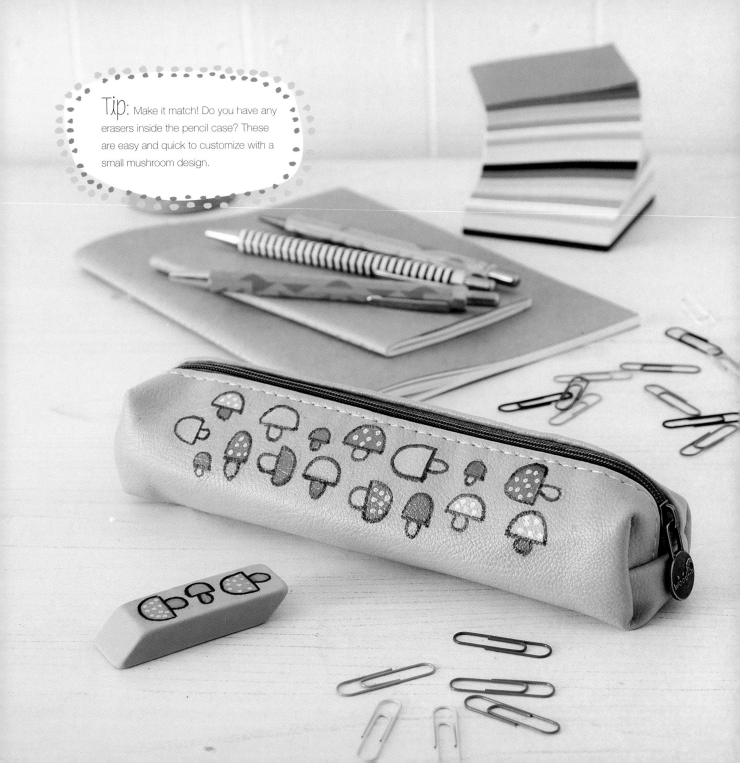

Tip: Make it match! Do you have any erasers inside the pencil case? These are easy and quick to customize with a small mushroom design.

Stationery Pencil Case

Suggested Sharpie: permanent marker

Decide which tools you want to
appear on your pencil case—you
could use your own pencil case
for inspiration! Start by drawing the
largest central items, such as the
fountain pen and scissors and then
fit the medium-sized tools, such
as the pencil and paintbrush, in
next. Finally, slot the small items,
like buttons and paperclips, in the
gaps in between. Use dark colors
for the small items and paler colors
for the largest.

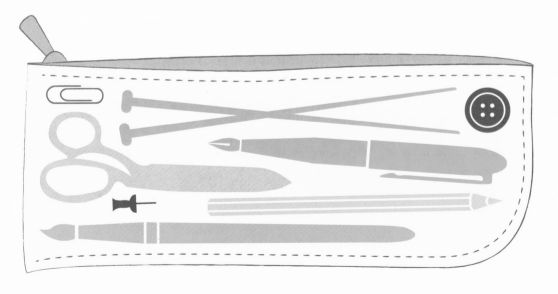

Graphic Pencil Pots

Suggested Sharpie: oil-based paint marker

Is there anything more satisfying than a tidy desk? Maybe a beautiful tidy desk! Use the illustrations here as a guide to help you build up the layers of the pattern for your chosen design. For the hexagons and flowers, start in the center of the pot and work outward from there. For the stripes and fans, start at the base of the pot and work your way up.

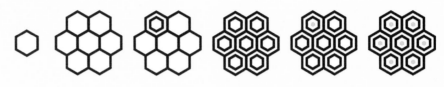

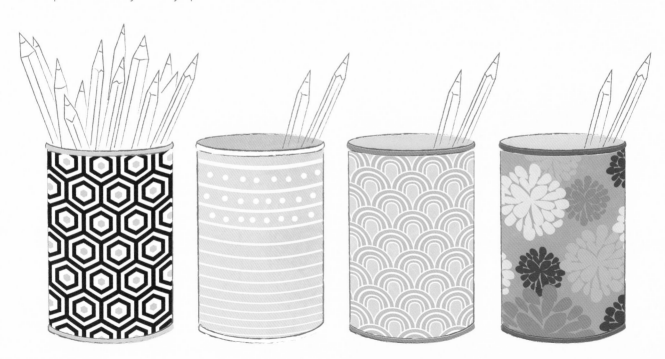

Fox Print Notebook

Transform a simple notebook into a favorite journal by adding these cute fox illustrations. Smooth notebook covers are easy to draw onto, but do test how the permanent marker ink sticks to the material. If it can be rubbed off easily, try using oil-based paint markers instead.

You will need:
- Notebook
- Pencil
- Paper (optional)
- Graphite paper (optional)
- Eraser (optional)
- Permanent or oil-based paint markers in colors of your choice

Skill level:

1 Lightly sketch the design directly onto the clean notebook cover with a pencil. Alternatively, draw the design on paper to transfer the outline to the cover later.

2 Start drawing the fox on the left. Draw a large circle for the head and, starting from the bottom center, draw two pointed ovals at a slight angle on either side of the bottom of the circle. Add the ears to the top of the head.

3 Draw in the body shape and arms.

4 Add another pointed oval to the side of the body for the tail. When coloring, leave the tip blank, or make it a different color than the rest of the tail.

 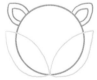 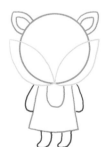 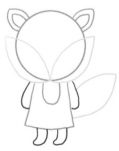

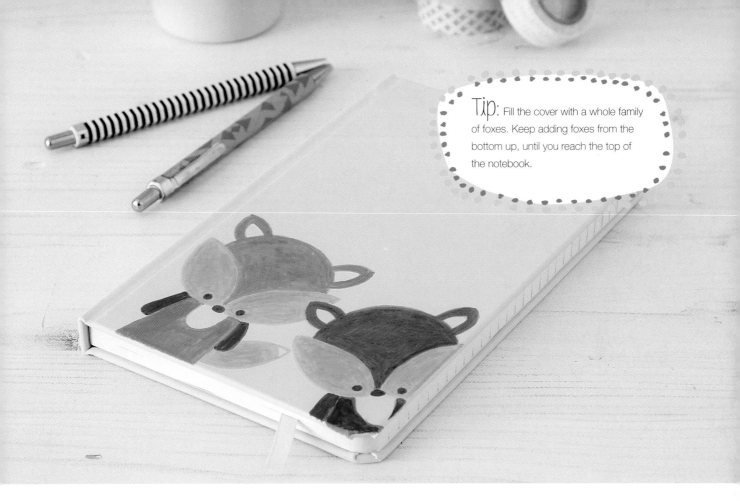

Tip: Fill the cover with a whole family of foxes. Keep adding foxes from the bottom up, until you reach the top of the notebook.

5 Following steps 1–4, sketch out another fox next to the first and at a slight angle.

6 Once you are happy with the overall design, transfer it to the cover of the notebook using the Graphite paper transfer technique (see page 12). If the pencil lines are too thick, go over them lightly with an eraser.

7 Pick out colors that go well with the color of your notebook and once you have tested them on the surface of the notebook and are happy with the result, start coloring the design. When you're finished, pick a darker permanent marker and add small circles for the eyes and noses.

Any Direction Clipboard

Where will your notes take you? Let these arrows lead the way. You don't need a lot of time to create this quick and easy design. Taking notes is fun!

You will need:

- Clipboard
- Ruler
- Permanent markers in three colors

Skill level:

1 Starting roughly ½in (1.25cm) from the top, use a ruler and permanent marker to draw two straight vertical lines on the left and right sides of the clipboard, about two thirds of the length of the board.

2 Draw five shorter vertical lines along the bottom of the board. Position the ones on the far left and far right directly beneath the lines above. Space the other three lines out evenly.

3 Using the same marker, draw all the outlines of the arrowheads and tails. Allow to dry.

4 Using the same marker, plus two other markers, color in the arrowheads and tails with solid ink. Play around by using different colors on the left and right sides of the arrows.

5 Finalize the design by adding a few short horizontal lines and vertical groups of dots around the arrows.

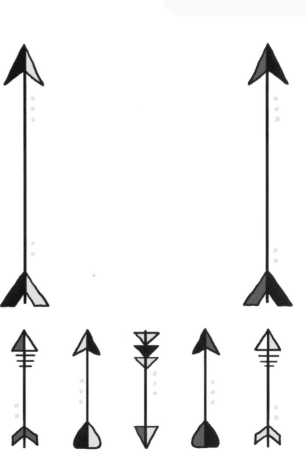

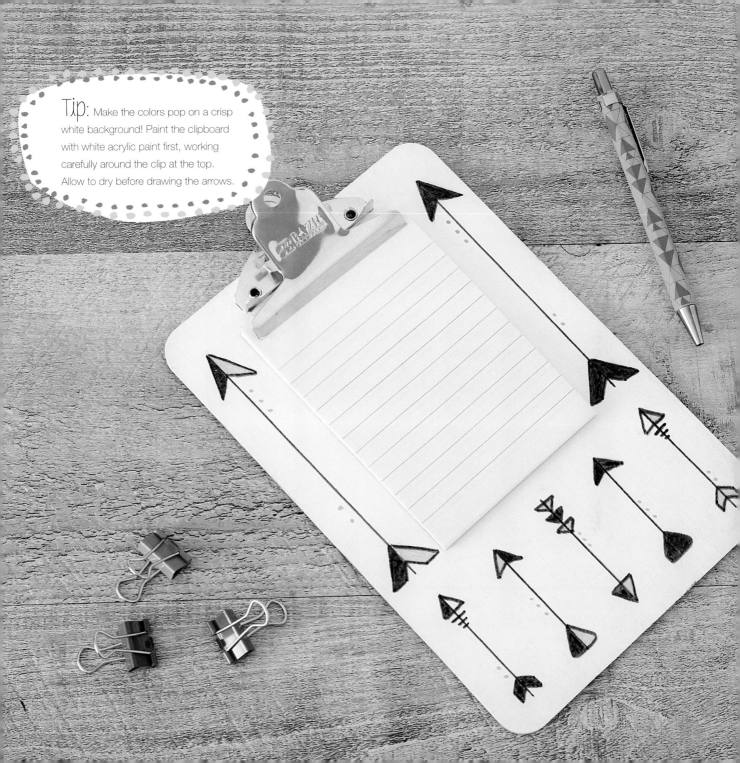

Triangle Notebook

Suggested Sharpie: permanent marker

Choose a range of bold colors and start at one edge of the notebook. Draw neat patterns in columns—play with dots, zigzags, and stripes to gradually build up an Aztec-style pattern, and after a few columns repeat the pattern you have just created until you reach the other edge.

Repeat pattern

Glasses Clipboard

Suggested Sharpie: oil-based paint marker

Start by painting your clipboard with a light shade of acrylic paint that will allow the glasses illustrations to pop. Allow to dry, then draw a pair of glasses roughly in the center of the clipboard and surround it with a range of different styles of frames. Mix up the colors to make the design really colorful. Feel free to rotate some of the frames so that they are both horizontal and vertical for added effect.

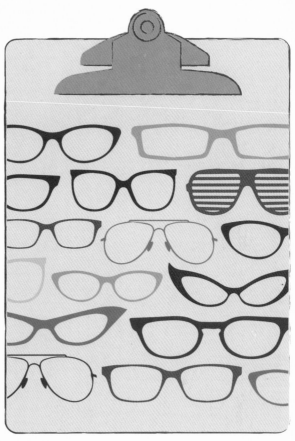

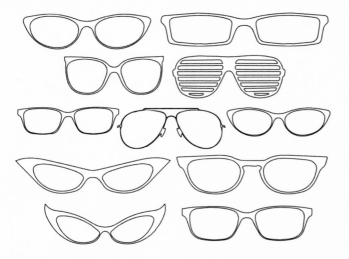

Colorful Gift Tags

Dress up your gifts with these decorative wooden gift tags. With easy-to-draw, colorful geometric patterns, these enticing designs will definitely be the first to get picked and unpacked at any party.

You will need:
- Gift tags
- Sealant
- Pencil
- Permanent or oil-based paint markers in the colors of your choice

Skill level:

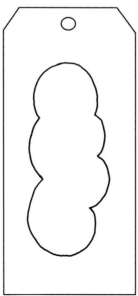

1 When using unfinished wooden tags, as used for the photograph, seal the wood first with sealant so that the ink won't bleed into the wood grain (see page 12). Skip this step for paper or cardboard tags.

2 Start by outlining an area in pencil that will be left blank to write the name of the gift recipient when finished.

3 Using a pencil, lightly sketch your geometric design of choice on the tag around the name area.

4 Go over the design with your markers. (See overleaf.)

Tip: Test a small area of your tags with a light color to see how your pens will work on the grain of the wood before drawing your design.

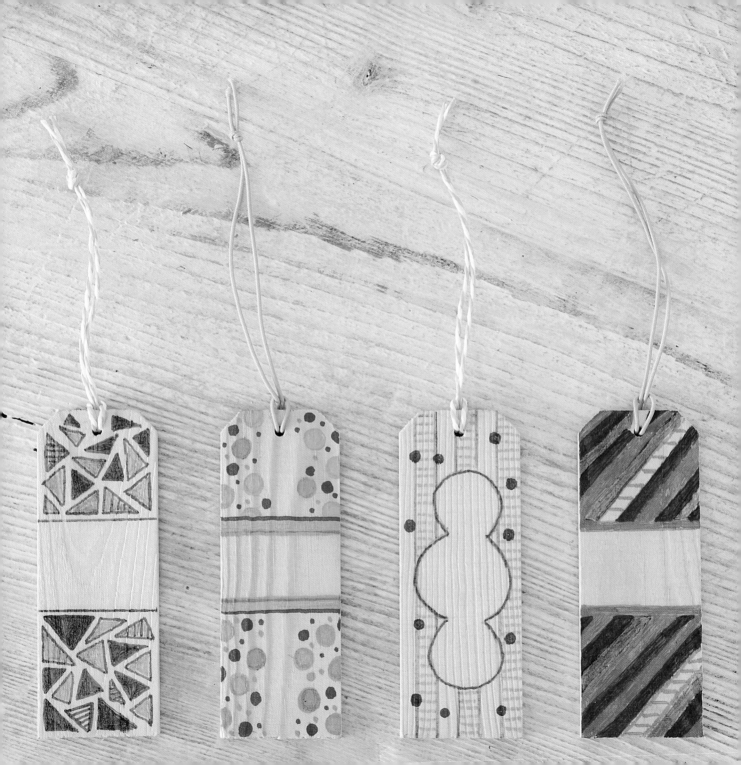

Quill Gift Tags and Envelope

Suggested Sharpie: permanent marker

What could be better than a hand-written letter enclosed in an envelope decorated with a quill pen? Start by drawing the central, curved line of the feather from nib to tip and then work in the feather shapes from this central curve. Add a fluid scribbly line under the nib as the finishing touch.

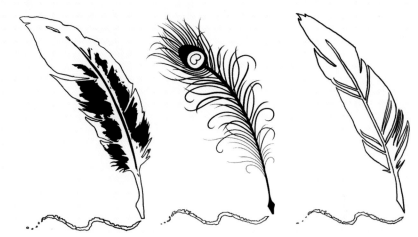

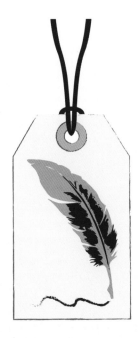

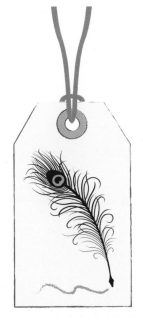

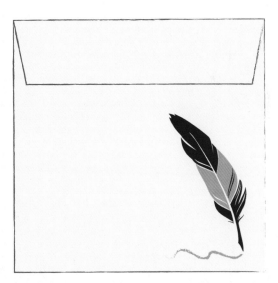

Celebration Gift Bags

Turn the bag into part of the gift by adding a decorative design. An ampersand symbol will look striking on the packing of a present for a wedding or anniversary.

You will need:

- Paper gift bag
- Ampersand template
- Adhesive tack
- Permanent markers in a variety of colors

Skill level:

1 Draw a large ampersand symbol on a piece of paper, or print out an ampersand in a large font size. Cut out the ampersand to make a template.

2 Use adhesive tack to position the template onto the bag. Hold the template securely in place, making sure it doesn't move while you draw dots around it. Alternatively, try using masking tape or Washi tape to keep the template in place.

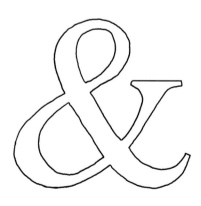

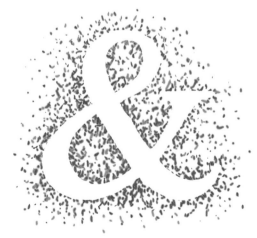

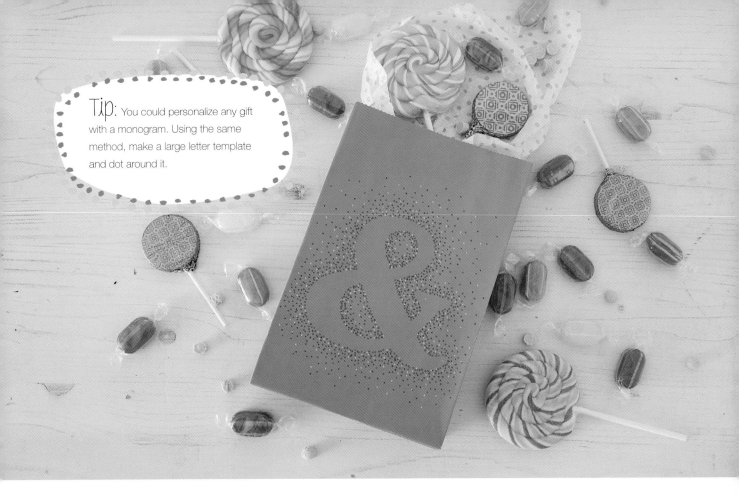

Tip: You could personalize any gift with a monogram. Using the same method, make a large letter template and dot around it.

3 Start drawing dots onto the bag. Concentrate the dots heavily around the edge of the template. This will give a distinct shape to the symbol when the template is removed.

4 Work the dots away from the template, making them less and less concentrated the further out they are.

5 When the first color is dry, choose a second color (and if you like, a third) and add more dots. Again, concentrate the dots heavily around the template and tapering as they spread outward.

6 Wait until all the ink is dry, then carefully remove the template from the bag. Put the gift inside and hand it over to the lucky recipient!

Petal Gift Boxes

Need an easy way to add a personal touch to a small gift? All it takes is a plain gift box and two permanent markers in different colors. Perfect for any occasion and great for making party favors.

You will need:

- Gift box
- Pencil (optional)
- Permanent markers in two colors

Skill level:

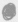

1 Lightly draw the design on the box with a pencil, or, if you're feeling brave, draw directly onto the box with your permanent markers.

2 Draw the outlines of the flower petals. Start with the center petal—a diamond shape with slightly rounded corners.

3 Next, draw the outlines of both of the side petals, followed by the little petal tips at the back.

4 Using a second marker color, fill in the flower petals.

5 Using the first color, draw a vertical line for the flower stem and the outlines of two leaves on each side. Work around the side of the box and repeat for as many flowers as will fit on the box.

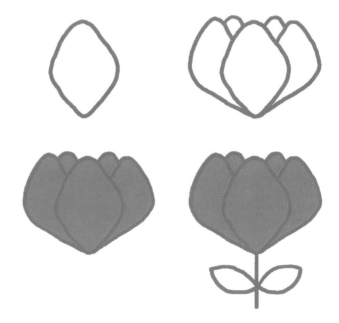

Tip: Mix and match! Gift boxes lend themselves to many designs. Here, you can see that the leaf design from page 94 has been added to one of the boxes.

Love Bug Gift Wrap

A sheet of paper filled with love bugs is the perfect wrapping for a birthday present for someone special, a baby shower gift, or a keepsake for a bride-to-be.

You will need:
- Paper large enough to wrap the present
- Pencil
- Paper (optional)
- Graphite paper (optional)
- Permanent markers in a variety of colors

Skill level:

1 Depending on how large your paper is, and how many times the design is to be repeated, you could sketch it directly onto the gift wrap. Alternatively, sketch the design on a piece of paper to transfer later.

2 Start sketching in the bottom left corner. Start with the outlines of the boxes.

3 Now for the love bugs. Start each one with a large circle, somewhat flattened at the bottom, for the face. Draw two smaller, solid circles on the lower part of the face for the eyes.

4 Beneath the face, draw two small half ovals for the arms. Connect these at the bottom with a curved line to section off the body. Finish with a small circle on each side for the bug legs.

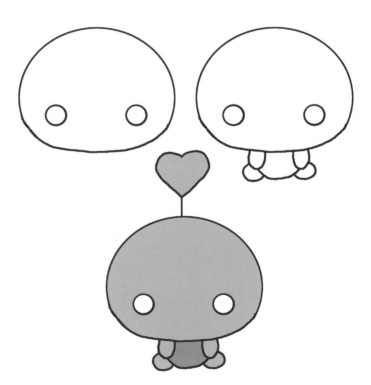

Tip: Short on time? Draw two love bugs and write the name of the recipient in a heart box. Quick, but still very loving.

5 Some bugs need a love antenna. Draw a heart above the bug and connect it to the head with a vertical line.

6 Balance the design by drawing hearts in some of the boxes.

7 If needed, copy the sketch to the gift wrap. If the gift wrap is light enough, just place it on top of the sketch and trace directly. Otherwise use the Graphite paper transfer technique (see page 12). Copy the design, move to the next area, and copy again. Continue this way until the gift wrap is full.

8 Using permanent markers trace the outlines of the boxes and color in the bugs and hearts.

Spiral Gift Box and Tag

Suggested Sharpie: permanent marker

Spirograph patterns can be used to create colorful images with layers of texture and detail. Choose a range of colors that complement one another— they could be clashing or shades of one color. Create geometric circular patterns of different sizes to create depth, and build up in layers to cover the box on all sides. Add a stripe around the edge of the lid for the finishing touch.

See the Colorful Gift Tags project on page 26 and the Petal Gift Boxes project on page 32 for more ideas for decorating gift boxes and gift tags.

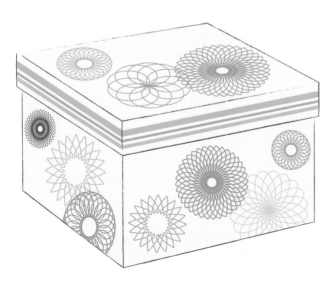

Jellyfish Gift Wrap

Suggested Sharpie: permanent marker

Design your own jellyfish motif, starting with the body, or umbrella as it is more commonly known, and finishing with the tentacles, which can be as wiggly as you like. Repeat the motif in rows on your gift wrap. For a uniform, geometric layout space the jellyfish evenly and try to replicate your jellyfish as exactly as you can. If you want a more fun, dynamic look use different sizes of jellyfish with different lengths of tentacles.

See the Love Bug Gift Wrap project on page 34 for an alternative way to decorate gift wrap.

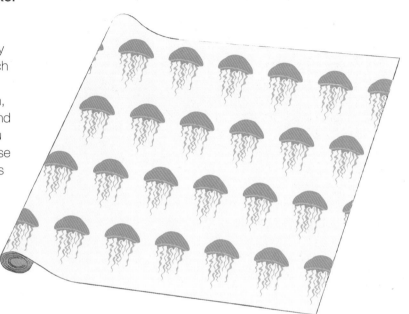

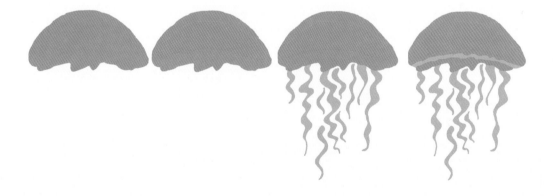

Aztec Dog Collar

Don't forget about the furry creatures in your life. Treat your dog as the star he is, and make him his own designer collar with this colorful Aztec-inspired pattern.

You will need:
- Leather (or faux leather) dog collar
- Rubbing alcohol
- Pencil (optional)
- Oil-based paint markers in a variety of colors

Skill level:

1 Give the dog collar a good scrub and wipe it with a little rubbing alcohol to make sure it is completely free of any oils and dust.

2 This design does not need to be sketched out first. The project lends itself perfectly to working directly on the collar; however, if you prefer, you could lightly draw the design onto the collar with a pencil first.

3 Draw a variation of lines, some narrow, some a little broader. Mix in a few vertical and horizontal triangles, and even some small blocked parts.

4 It is best to work in one color at a time, leaving space for shapes in the other colors. Allow each color to dry completely before moving onto the next. You may need to add several layers of paint to make the colors really vivid. Work carefully around the metal parts of the collar. Work from one side of the collar to the other, moving along carefully and making sure you don't rub over the ink while it's still wet.

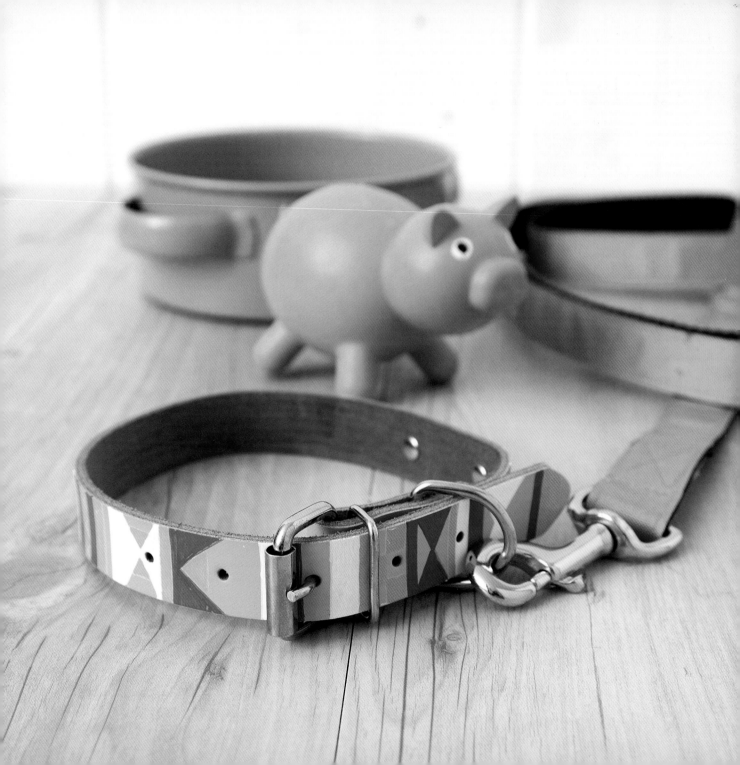

Flamingo Headphones

Flamingos may not be known for their amazing singing ability, but they sure do love music. Show them some love by adding a flamingo to both sides of your headphones. Rock out!

You will need:
- Light-colored headphones
- Pencil
- Paper (optional)
- Graphite paper (optional)
- Oil-based paint markers, pink and one other color

Skill level:

1. Start by drawing the flamingo on paper in order to transfer its outlines onto the headphones later. Alternatively, you could use a pencil to sketch the design directly onto the headphones.

2. To draw the flamingo, start with the head, drawing an almost-circle, with parallel lines curving smoothly from it into the backward S shape of the long neck. At the end of the neck, draw an oval shape with a pointed end for the flamingo's body and tail.

3. At the bottom, draw a vertical line, ending in a short horizontal line for the leg the flamingo stands on. The second leg starts at the same point on the body and is a diagonal line that turns into a horizontal line, ending with a short vertical line.

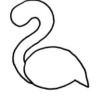

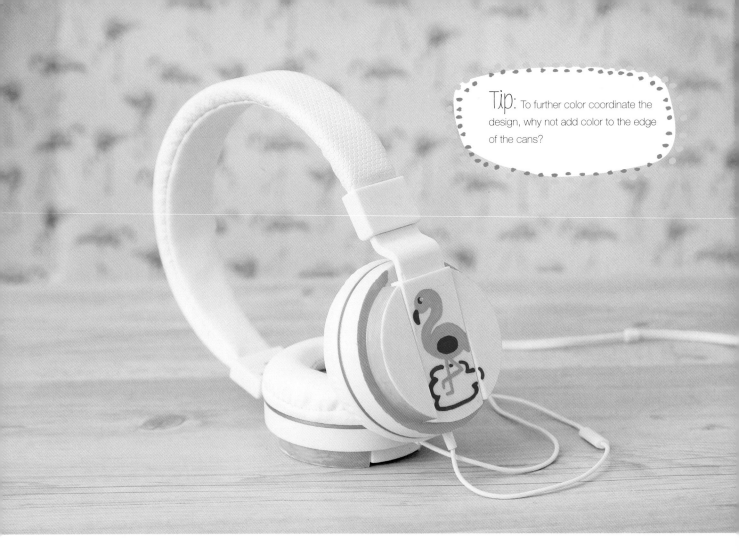

Tip: To further color coordinate the design, why not add color to the edge of the cans?

4 Sketch the details for the flamingo's eyes, beak, and wing. Draw a cloud-like shape to give the flamingo a little pool of water to stand in.

5 Transfer the outlines to the headphones using the Graphite paper transfer technique (see page 12).

6 Use a pink oil-based paint marker to trace over the lines of the flamingo's head, neck, legs, and body. Use a second oil-based paint marker in a color of your choice to draw the eye, beak, wing, and water pool. When this is dry, use the pink marker to color in the flamingo.

Nature Print Skateboard

Perfect for the skateboarders out there who like to customize their own decks, this is a great project to do on your own or to collaborate on with a friend who can help color in!

You will need:

- A skateboard deck
- White spray paint (optional)
- Pencil
- Permanent markers including neon and metallic colors
- Masking tape
- Oil-based paint marker in white (optional)
- Sealant (optional)

Skill level:

 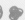

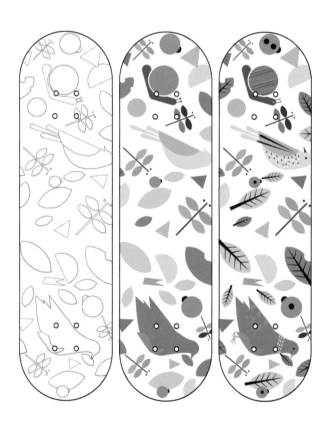

1 Start with a plain white skateboard deck; if you don't have a plain one, you can spray over the previous artwork with white spray paint. You will find it easier to work if you remove the trucks.

2 Wipe the skateboard with a clean damp cloth; this is to make sure there are no unwanted specks or dust on the surface.

3 Roughly sketch the artwork on the skateboard with a pencil, so that you can see which element sits where.

Tip: You may find that the surface of the skateboard deck is too glossy to draw onto. If this is the case, use sandpaper to sand down the area you are going to work on before you start.

4 Start blocking in color in the areas of the design that have a base color. You may need to use masking tape to mark out some areas to achieve clean lines.

5 Once the first base colors have dried, start adding the pattern and details. Use metallic colors for the pigeon and songbird and neon shades for the abstract patterns.

6 When you have completely covered the skateboard with illustrations and the ink has dried, use a damp cloth to carefully wipe away any marks you may have left while coloring in. If that doesn't work, then use the white oil-based paint marker, which works very well for correcting and cleaning up lines. Add a layer of sealant to the design for greater durability.

Hanging Decoration

The most special room in the house, the nursery, gets a playful, handmade touch with this easy-to-make and captivating decoration.

Safety first: This is a decorative piece only. Hang it well out of baby's reach and not directly above a cot or crib.

You will need:
- Large wooden embroidery hoop (inside hoop only)
- Cardstock
- Scissors
- Pencil
- Hole punch
- Permanent markers in a variety of colors including black or brown
- Embroidery floss

Skill level:

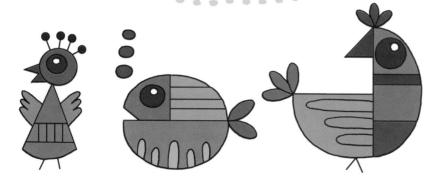

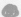

1 To make the decoration, draw four 4in (10cm) circles on the cardstock and cut them out. Punch a hole in the top of each circle.

2 Sketch one of the animals in pencil on each circle. Start with the outlines and then add details. After sketching, go over the outlines with the permanent markers then fill in the color.

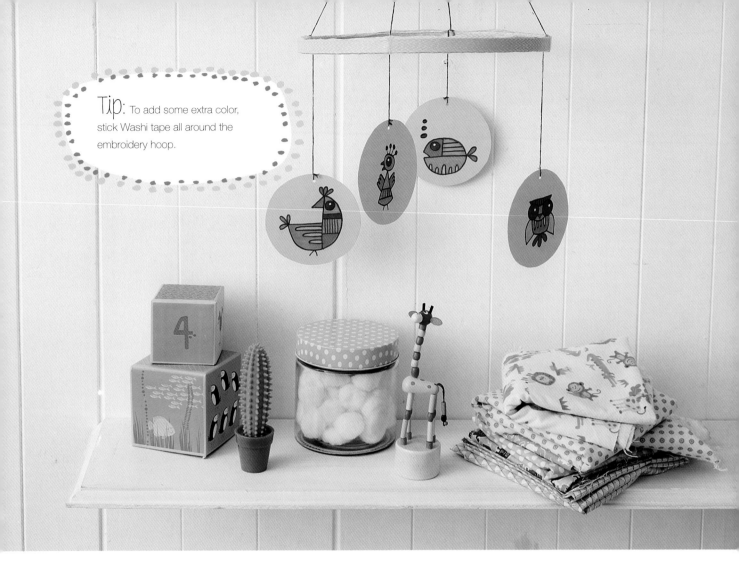

Tip: To add some extra color, stick Washi tape all around the embroidery hoop.

3 Cut four 10in (25cm) strings of embroidery floss and thread them through the punched holes. Tie the ends of the strings to the embroidery hoop distributing them evenly around the hoop.

4 Once all of the circles are attached to the decoration, cut four more 10in (25cm) strings of embroidery floss and attach them to the hoop where the other strings are. Tie the ends together, and form a loop to hang the decoration.

Toothbrush Toiletry Bag

Suggested Sharpie: permanent marker

Lay your wash bag as flat as possible. Slide a sheet of card inside to give you a nice flat surface to work on and to prevent any ink from bleeding through. Start by drawing in the "hero" toothbrush: Draw the shape for the handle first, then work in the toothpaste swirl, and finish off with the brush hairs to join them together. Repeat the design in diagonal lines until your design covers the whole bag.

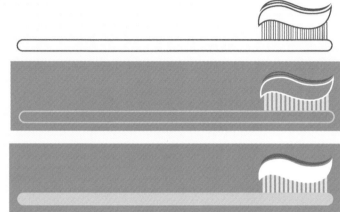

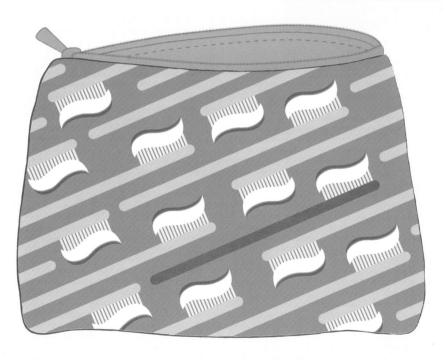

Swallow Cosmetics Bag

Suggested Sharpie: permanent marker

Follow the instructions opposite, and lay your make-up bag as flat as possible. Perhaps slide a sheet of card inside to give you a nice flat surface to work on and to prevent any ink from bleeding through. Start by drawing in the "hero" swallow: Color the shape for his tummy first and then build up the dark grey of his body on top. Then draw the remaining swallows in neat rows anchored by the hero bird.

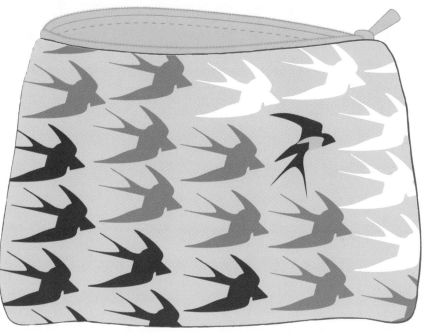

Geometric Storage Jar

What is prettier than a geometric triangle design?
A multi-colored triangle design! Use a variety of
bright and sunny colors for a lively look. All that's
left is to decide what to fill the jar with.

You will need:
- Storage jar
- Oil-based paint markers
 in a variety of colors
- Sealant (optional)

Skill level:

1 Before you start, make sure that the jar
 is thoroughly clean.

2 Choose a palette of rainbow colors to
 draw the triangles with. Work directly
 onto the jar and start by drawing just
 the outlines. Mix up the colors, so that
 no triangles directly next to each other
 are the same color.

3 Randomly fill some of the triangles
 with solid color, and others with lines
 or crosshatching. You may need two
 layers of paint to make the colors really
 stand out.

4 Mix in a few small dots alongside
 the triangles.

5 Leave to dry completely. For extra
 protection, add a light layer of
 sealant or use the Heat-setting
 glassware technique (see page 14).

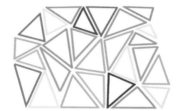

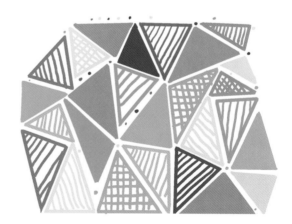

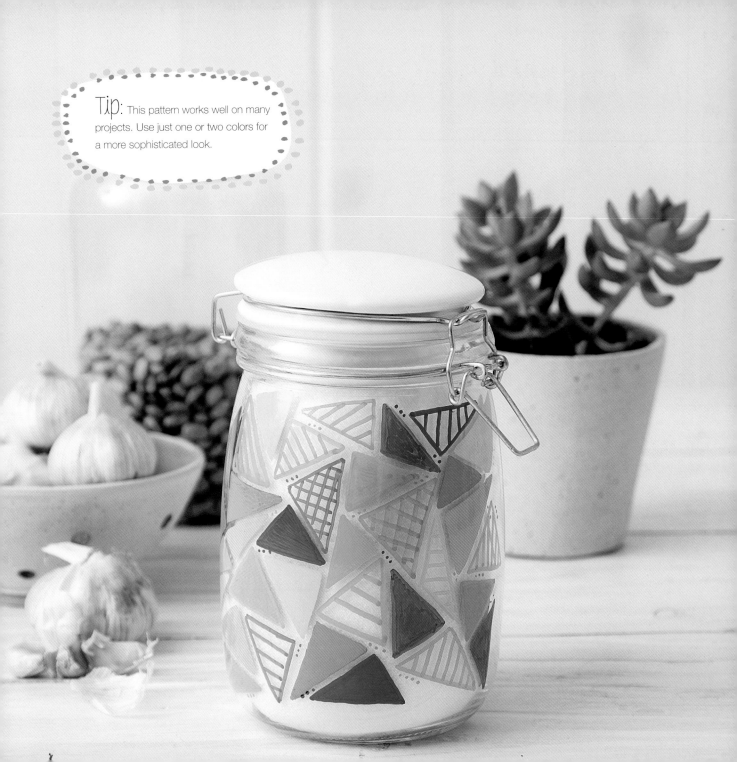

Tip: This pattern works well on many projects. Use just one or two colors for a more sophisticated look.

Retro Utensil Holder

Create a stunning mid-century look with this 1950s-inspired design. Using bright contemporary colors gives it an up-to-date and current feel that will be a colorful addition to any kitchen.

You will need:

- Utensil holder
- Pencil
- Paper (optional)
- Graphite paper (optional)
- White acrylic paint and brush or oil-based paint marker
- Permanent and/or oil-based paint markers in bright colors and black
- Sealant

Skill level:

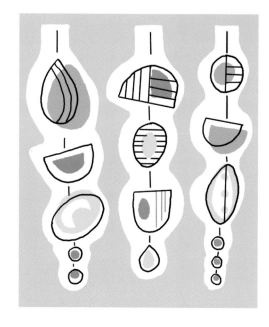

Tip: Add some color to the handles of your wooden spoons to make them match the holder. Use a piece of tape to get crisp lines.

1 Lightly sketch the outline of the white background area directly onto the clean utensil holder. Alternatively, draw it onto a piece of paper and transfer to the utensil holder using the Graphite paper transfer technique (see page 12).

2 Using a brush or oil-based paint marker, apply a layer of white paint to the pencil outline then fill in the shape with more paint. You may need a few coats to cover the background.

3 When the base paint is dry, draw the outline of the pattern with a pencil. Add the three different color shapes to the design. Go over them twice to get thicker coverage and allow them to dry.

4 Following the design, draw outlines in black around the colored parts, making sure they are slightly off-center. Add vertical lines in-between the images to connect them like a garland.

5 Once the ink is dry, apply a sealant as the utensil holder will probably live on the kitchen counter.

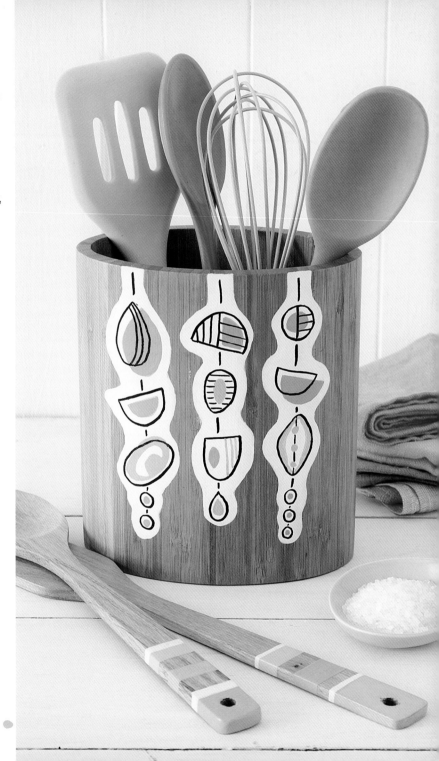

Snap–Happy Suitcase

Revamp your suitcase, and always be the first to spot your luggage on the airport carousel! Happy traveling, and don't forget to take lots of pictures.

You will need:
- Suitcase (new or vintage)
- Pencil
- Oil-based paint markers in a variety of colors

Skill level:

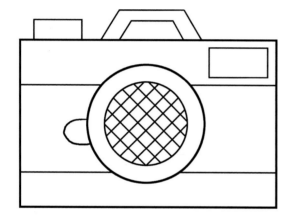

1 Using a pencil, lightly sketch the camera design onto a clean suitcase. Start by drawing one large rectangle shape as the base for the camera.

2 Draw two circles, one inside the other, for the lens. Add diagonal crosshatching inside the smaller circle. Next, draw a half oval on the side of the large circle as a button.

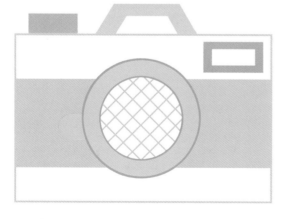

3 Add the flash box and button shapes and draw two horizontal lines on the base of the camera, going behind the lens.

4 Pick your oil-based paint marker colors and start tracing over the sketch and adding colors. Leave each color to dry completely before moving onto the next.

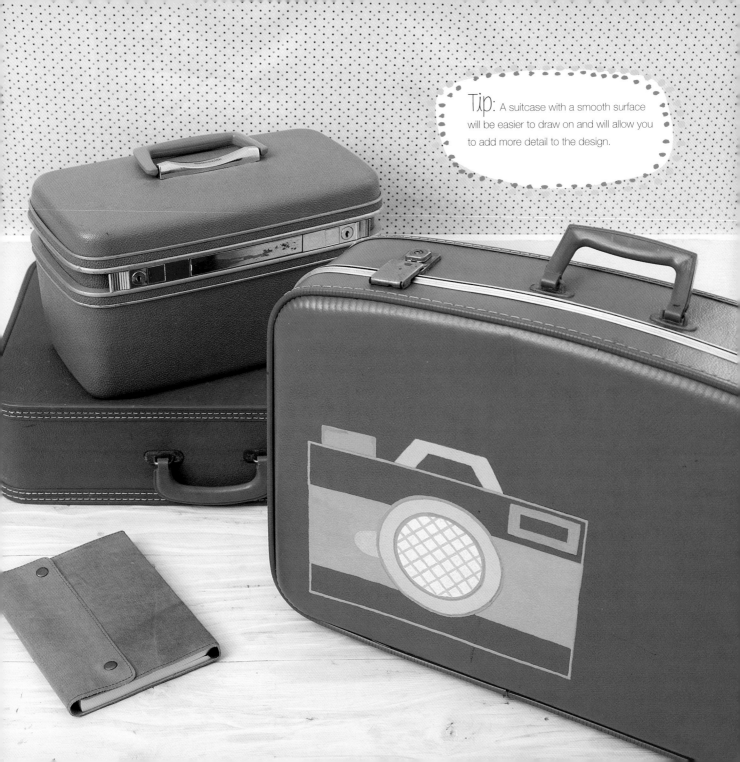

Tip: A suitcase with a smooth surface will be easier to draw on and will allow you to add more detail to the design.

Mid-Century Style Platter

Add a splash of mid-century panache to your home using this stylish platter decorated with images of mod kitchenware.

1 Make sure the tray is completely clean. Wash it and wipe with rubbing alcohol.

2 Measure the borders of the tray. Cut out four pieces of paper the same size as the border edges: two should be the same dimensions as the top and bottom borders, and two the same dimensions as the sides.

3 Decide which kitchen images will go on the platter. Draw your images of choice on the pieces of paper.

4 Using the Graphite paper transfer technique (see page 12), transfer all four border sketches onto the tray.

5 Use permanent markers to trace the outlines and color them in.

6 Let the ink dry completely, then use the Heat-setting ceramics technique (see page 13).

You will need:

- Ceramic platter
- Rubbing alcohol
- Pencil
- Paper
- Graphite paper
- Oil-based paint markers in three colors

Skill level:

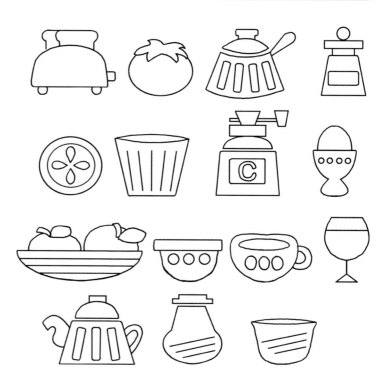

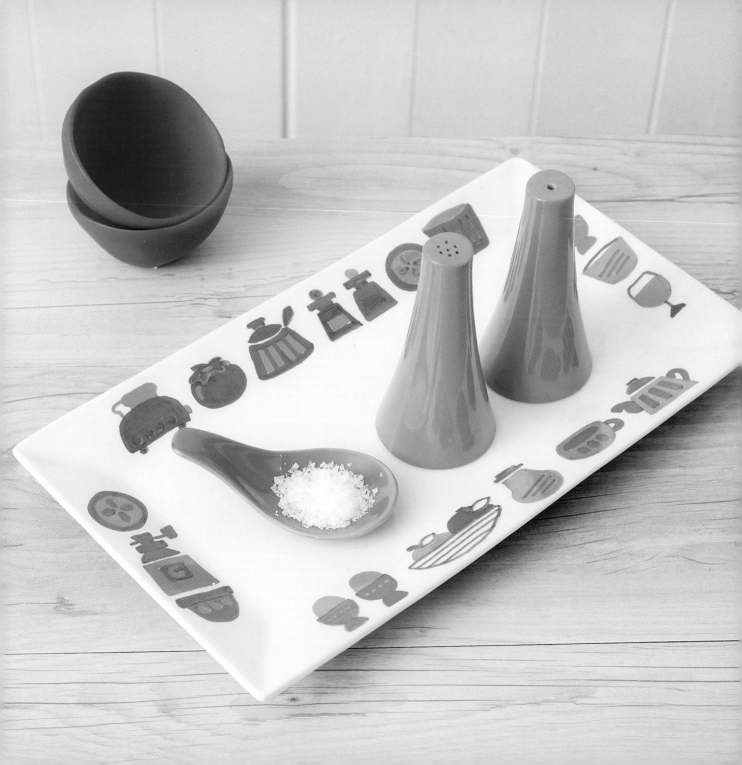

Summery Storage Box

This project is a fun way of brightening up a plain storage box. Create your own pattern or use this ice cream theme to make a bright and cool design!

You will need:

- Flat-pack storage box
- Pencil
- Paper
- Graphite paper
- Ultra-fine permanent marker in black or brown
- Eraser
- Selection of permanent markers in bright colors

Skill level:

1 Keeping the box flat, sketch the ice cream outlines onto paper and transfer to the box using the Graphite paper transfer technique (see page 12), in a repeating pattern.

2 Use the ultra-fine permanent marker to draw over the pencil lines.

3 Allow the ink to dry completely and carefully erase any visible pencil lines.

4 Use the permanent markers to color in the ice cream.

5 Draw confetti shapes in the blank spaces between the ice cream using the same colored pens as you did for the ice cream.

6 Assemble the box according to the manufacturer's instructions.

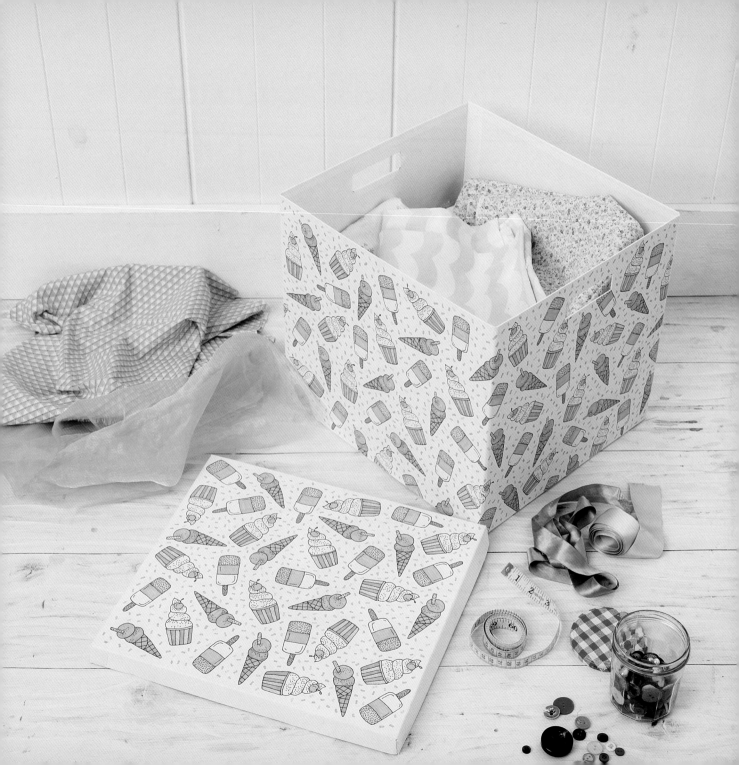

Triangle Print—Lined Suitcase

Suggested Sharpie: permanent marker

Think outside the box (or case) and create an explosion of color inside your suitcase. Choose five colors of varying shades that complement one another—perhaps using one color that matches the outside of your suitcase. Start somewhere in the center of your material and draw a hexagon that is made up of ten triangles—use all five of your chosen colors within the hexagon (a hexagon has been isolated in the illustration). Then gradually build up more hexagons around the original one and continue until you have covered the inside of your case.

See the Geometric Storage Jar project on page 48 for more ideas using geometric designs.

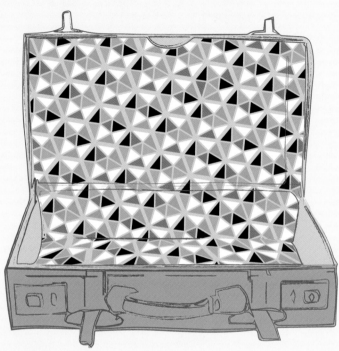

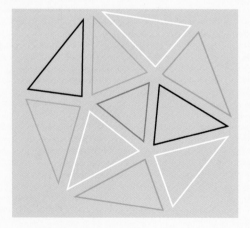

Popcorn Storage Boxes

Suggested Sharpie: permanent marker

Use red, yellow, blue, and white to create these popcorn-themed storage box designs. For the striped box use a ruler to measure ¾in (2cm) wide stripes all the way around the box and color in the red stripes. For the popcorn boxes, begin by coloring in the background with your base color, then draw in the outline of the popcorn pieces using a white pen—experiment with tightly spaced popcorn pieces and widely spaced pieces. Finally, fill in the popcorn-shaped pieces using white, and color or paint the lids in a contrasting color.

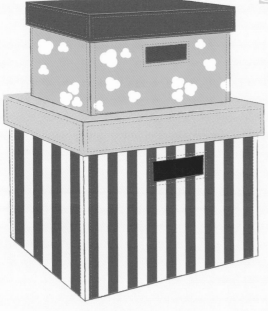
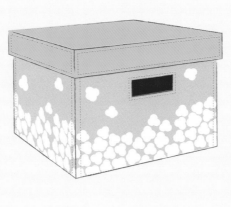

Up in the Air Flowerpots

These pots are a great beginner project and would make the perfect gift for the gardener in your life. Start with a basic flowerpot and turn it into a special treasure. Happy planting!

You will need:
- Clay flowerpots
- White acrylic paint
- Gold acrylic paint
- Paintbrush
- Pencil
- Paper
- Graphite paper
- Permanent or oil-based paint markers in three different colors

Skill level:

1 Start by giving the pot two coats of white acrylic paint. Apply two coats of gold paint to the rim. Allow to dry.

2 Once the paint is fully dry use the Graphite paper transfer technique (see page 12) to draw the hot air balloon outline on the pot.

3 To draw the balloons, start with the middle. Draw a vertical oval with a pointed bottom and flat, rounded top. Then draw crescent shapes to the left and right, leaving a little space in-between the shapes.

4 Draw a short vertical line from the bottom tip of the oval. At the end of the line draw a half circle to represent the air balloon's basket.

5 Color in the balloon outlines. Because of the painted background, oil-based paint markers will go on very smoothly, but permanent markers can also be used for the design.

6 Finalize the design by adding a small circle to the top of each balloon, and drawing five short horizontal lines in the blank spaces within the balloon shapes to link them together. To ensure the ink doesn't run when the plants are watered use the Heat-setting ceramics technique (see page 13).

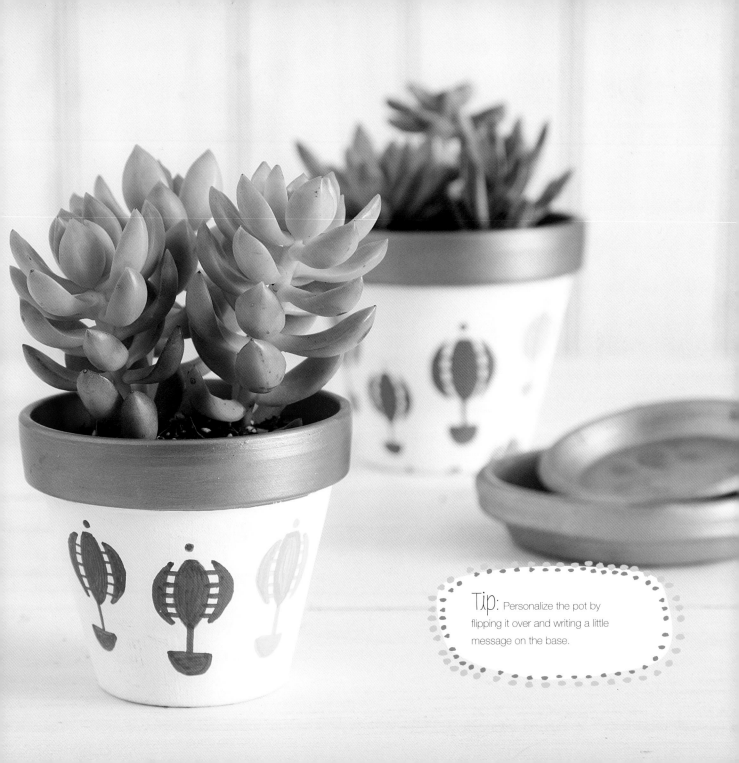

Tip: Personalize the pot by flipping it over and writing a little message on the base.

Heart Picture Frame and Print

Create a simple yet adorable piece of customized art. All you need is some paper, a few permanent markers in different colors, and a picture frame.

You will need:

- Square picture frame
- Paper—white for drawing on, colored for matting
- Scissors
- Pencil
- Permanent markers
- Oil-based paint marker

Skill level:

1 Cut out the colored paper to fit the inside size of the frame. This will be the picture's background. Next, cut out the white paper to a slightly smaller size, so that when placed inside the frame, a colored border is visible.

2 Lightly sketch the design onto the white paper using a pencil. Start with the two figures, beginning with oval shapes for the heads. Next draw the hoods, and then add the outfits beneath the heads, first the body and then the arms. Add feet and faces, and finish off with the little heart and pocket motifs.

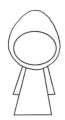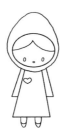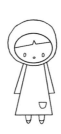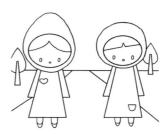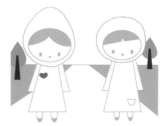

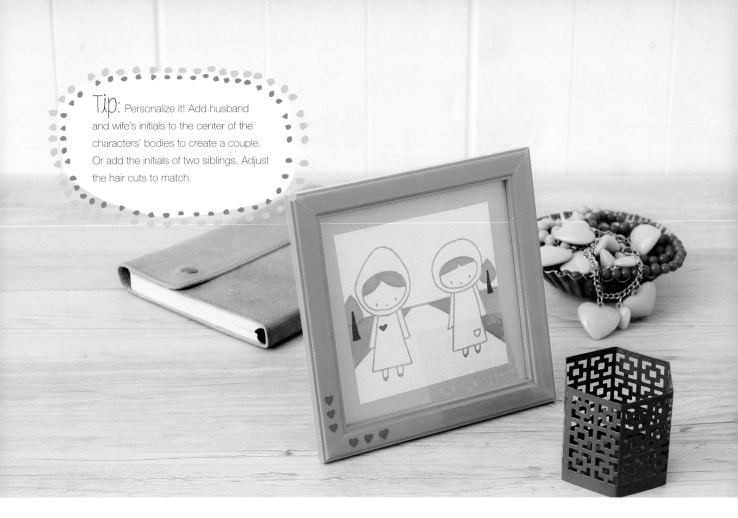

Tip: Personalize it! Add husband and wife's initials to the center of the characters' bodies to create a couple. Or add the initials of two siblings. Adjust the hair cuts to match.

3 Add a horizon line behind the two figures. Two short diagonal lines make the path they are standing on. Finish the drawing with the two trees in the background.

4 Pick your permanent marker colors and go over the sketch. Leave the figures as outlines and add solid color to the trees and grass.

5 Put the drawing in the frame, and choose an oil-based paint marker to match the colors of the print.

6 Using the oil-based paint marker, add a few hearts to the frame and it is ready to hang on the wall!

Rise and Shine Photo Frame

Suggested Sharpie: oil-based paint marker

For this design, start by marking in the horizon line, featuring outlines of flowers and blades of grass. Then, using a darker color draw the beehive in one corner. Finish the design by drawing a sun hugging the mount and a scattering of insects, such as bees and butterflies. Alternatively, customize your design to match the picture or photograph you will be featuring inside your frame.

Fruit Print Planters

Suggested Sharpie: permanent marker

These colorful planters will brighten up any garden. Decide how many pieces of fruit or veg you want to feature on the front of your planter and draw the outlines of each item. Once you are happy with the positioning, fill in the main colors. Draw in the leaves and stems in a dark green or brown, and add little dots and marks to add texture and detail.

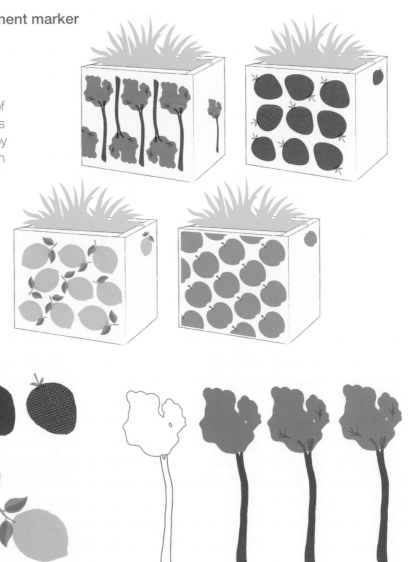

Shades of Blue Soap Dispenser

Add some elegance to your bathroom with this high-impact design. A fun project that's easy to do, and won't take a lot of time to finish.

You will need:
- Glass soap dispenser
- Rubbing alcohol
- Pencil
- Paper (optional)
- Graphite paper (optional)
- Oil-based paint markers in a variety of colors, including black
- Sealant (optional)

Skill level:

1 Make sure the glass is clean. Wash it and then wipe it with rubbing alcohol.

2 Draw the design on paper to transfer later. Or, if possible, lightly sketch the design directly onto the dispenser.

3 Start by drawing a large, pointed oval shape (somewhat like a teardrop), with the tip pointing down. Draw a vertical line straight through the middle. The line should extend past the top and bottom of the shape. Add a small circle to both ends of the line.

4 On either side of the pointed oval draw a similar, but smaller, oval with the tip pointing up. Draw a short vertical line protruding from the tip. Add a small circle to the end of that line.

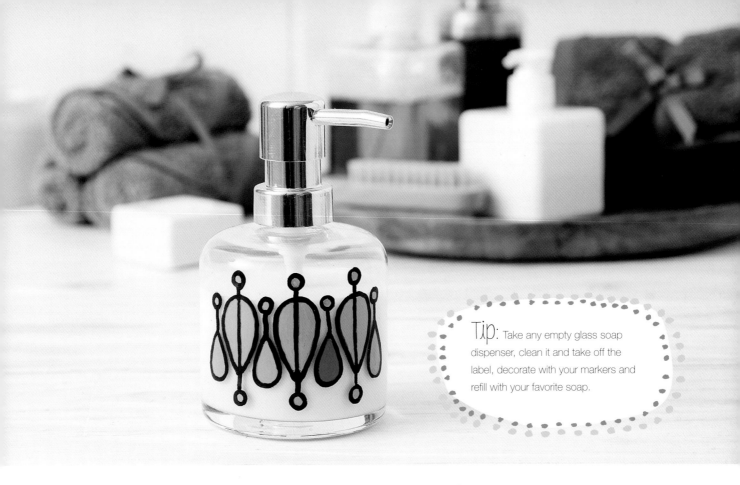

Tip: Take any empty glass soap dispenser, clean it and take off the label, decorate with your markers and refill with your favorite soap.

5 If needed, transfer the design onto the soap dispenser using the Graphite paper transfer technique (see page 12). Use a black oil-based paint marker to go over all the outlines. Leave to dry.

6 Choose a main color for the ovals and use that to color in all ovals except for one. Fill that last oval with a complementary color. Finish the design by adding color to the inside of the small circles.

7 Let all paint dry completely. For extra protection, add a light layer of sealant to the design, or, if appropriate, remove the lid and use the Heat-setting glassware technique (see page 14) for the glass body.

Chevron Bookends

A broad chevron looks a lot like an open book. What better place to draw lots of them than on a pair of bookends? These also make great tablet stands.

1 The bookends shown here have a base layer of yellow acrylic paint on the front and green oil-based paint marker color on the sides. This is optional; you could leave the bookends unpainted, or choose a different color for the base.

2 Use a ruler to draw the chevron shapes: Start by drawing the two outer vertical lines, then the middle vertical line just a little lower than the first two. Then connect the lines by drawing four horizontal diagonal lines in-between. Take care to align the chevrons with one another.

3 To speed the process up, draw assembly-line style. Moving the ruler from top to bottom, draw all the left vertical lines first, leaving a consistent space between them. Then draw all the righthand vertical lines at the same height. Continue in the same way with the central and horizontal lines.

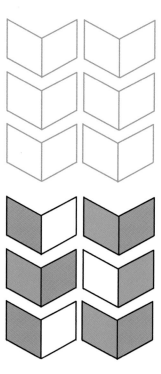

4 When you have drawn all the chevrons, use a dark-colored marker to go over all of the outlines.

5 Using three different markers, color in all the chevrons. Alternate the colors in such a way that a color is not repeated directly next to it.

Tip: If your bookends are made of unfinished wood, the markers will work, but they could bleed into the wood grain if applied directly. Apply a coat of sealant or paint first, so that the ink goes on smoothly.

Hello, Deer! Dresser Knobs

Paint markers are great for creating little home décor details. These deer-head knobs are a quick and simple update for any dresser.

You will need:

- Dresser knobs with a surface area of 2in (5cm) diameter or larger
- Pencil
- Paper (optional)
- Graphite paper (optional)
- Oil-based paint markers in three colors
- Sealant (optional)

Skill level:

1. Start by drawing the deer design on paper to transfer onto the knobs later. Or, if possible, lightly sketch the design directly onto the knob.

2. Draw the deer's head. Begin with a slightly curved horizontal line, and then add lines curving downward on each side, until they meet in the middle at the bottom of the head.

3. Draw an ear on each side of the head, and two curved lines beneath the face for the shoulders. Draw a triangular shape on the forehead, which ends with the nose. Draw a small vertical line from the nose to the bottom of the face.

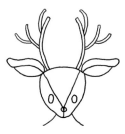

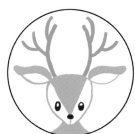

Tip: If you would like to make a number of decorated knobs, keep the deer design the same, and just vary the color scheme.

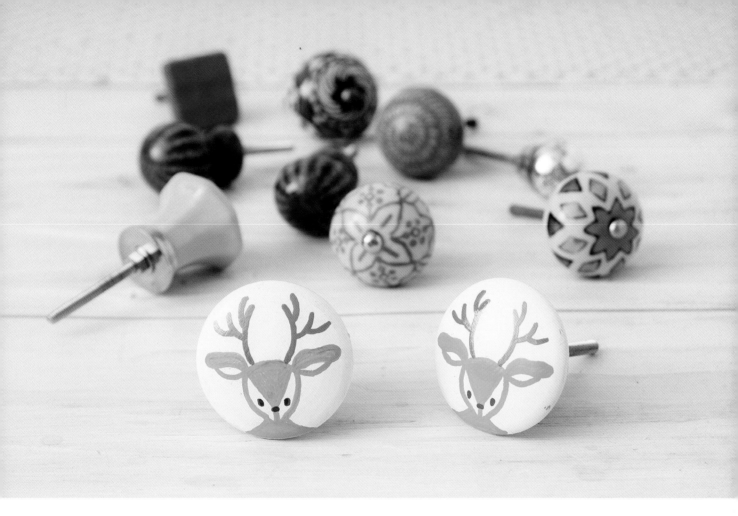

4 Draw curved parallel lines for the antlers, with more lines branching off.

5 If needed, transfer the outlines onto the knob using the Graphite paper transfer technique (see page 12). Choose a main color for the deer and use it to go over all of the face outlines.

6 Use a second color for the antlers, and a third color, preferably something dark, for the nose and eyes.

7 Leave to dry completely. For extra protection, add a light layer of sealant before attaching the knob to the dresser.

Ceramic Display Plate

A basic ceramic plate gets a makeover with a bold repeating border. Decorate one plate, or an entire set; this design works just as well on flat plates as it does on deep plates or small plates and saucers.

You will need:

- White ceramic plate
- Pencil
- Paper (optional)
- Graphite paper (optional)
- Oil-based paint markers in four colors, including one dark color

Skill level:

1 Divide the plate's border into eight equal sections. Do this by drawing a cross, top to bottom and left to right, with the pencil, only drawing the line on the border section of the plate. Rotate the plate by 45 degrees and draw another cross in the same way.

2 Draw the design on paper to transfer to the plate later. Or, if possible, lightly sketch the design directly onto the plate.

3 Start by drawing a vertical pointed oval with the tip pointing down. On both sides of the first shape, draw similar pointed ovals at 45-degree angles—as if they are coming from behind the first shape. Behind those, add two more ovals, this time at a 90-degree angle in relation to the first shape.

4 If needed, transfer the design onto the plate using the Graphite paper transfer technique (see page 12). Place the image on each of the eight sections marked on the border of the plate.

5 Use a dark colored oil-based paint marker (dark blue is used here) to draw over the eight section lines on the plate's border. Next, draw over all the designs, alternating between two or three different colors. Color in the central and outside ovals with solid color.

6 Let all the paint dry completely. For extra protection use the Heat-setting ceramics technique (see page 13).

Watercolor Throw Pillow

Spruce up your home with this unique decorative pillow. You can transform a plain white throw pillow into a striking eye-catcher with this watercolor-style portrait of a lady.

1 Wash and iron the pillowcase and place it on a flat surface with a piece of cardboard inside it to prevent the ink from bleeding through.

2 Draw the outline of the design on paper to transfer onto the pillow later. Or use a pencil to sketch directly onto the fabric.

3 Start by outlining the hair. Add a rounded line to the bottom, marking her chin and the bottom of her face. Draw a line on the right for her neck, and add the collar and tops of the shoulders.

You will need:

- White or light-colored cotton pillowcase
- Iron
- Cardboard
- Pencil
- Paper (optional)
- Graphite paper (optional)
- Permanent markers in a variety of colors
- Rubbing alcohol
- Paintbrush
- Black fabric marker

Skill level:

Tip: For a simpler version, why not use the Watercolor effect technique for the full surface of the pillow?

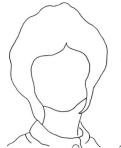 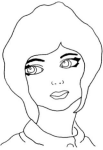 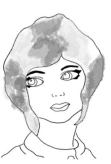 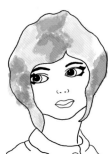

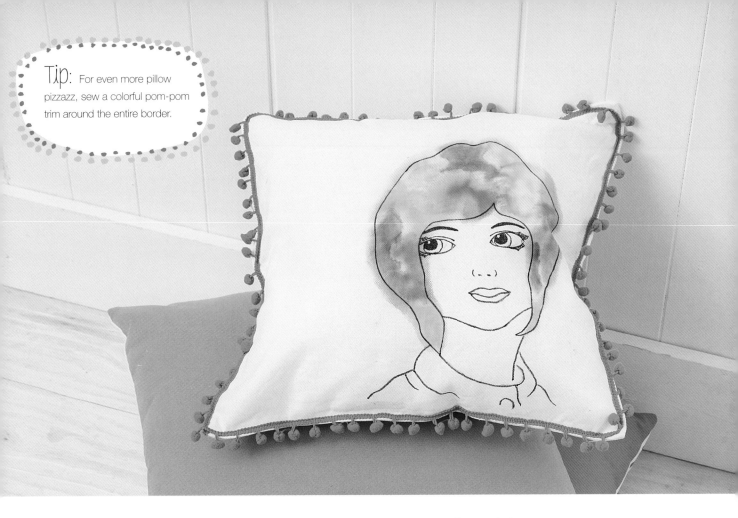

Tip: For even more pillow pizzazz, sew a colorful pom-pom trim around the entire border.

4 Draw the lips, nose, and eyebrows, and draw an oval for each eye. Add circles for the iris and pupil. Draw broad, rounded lines for the eyelashes and finish with slightly rounded lines to mark her eyelids.

5 Transfer the design onto the pillowcase using the Graphite paper transfer technique (see page 12).

6 Use the Watercolor effect technique (see page 13) to add color to the hair area. Be patient and let the colors completely dry before starting on the line drawing.

7 Using a black fabric marker, go over all the lines of the design. Let the ink dry, and use the Heat-setting technique (see page 13).

Green Fan Pillow

Suggested Sharpie: oil-based paint marker

Remove the cushion from its case, and lay the case as flat as possible; slide a sheet of card inside to give you a good flat surface to work on and to avoid the ink bleeding through. Start near the center of the cushion and begin drawing your first "fan" shape. Start with the largest dot at the point and build up curved rows using smaller dots for each row, and progressively lighter shades of ink to create the faded effect.

Hot Air Balloon Floor Cushion

Suggested Sharpie: permanent marker

Remove the cushion from its case, and lay the case as flat as possible. Slide a sheet of card inside to give you a good flat surface to work on and to avoid the ink bleeding through. Start somewhere near the center of the cushion and begin drawing the first hot air balloon (see page 60 for an even easier template). For the striped balloons start with the central stripe and work outward to create the balloon shape, finishing off with the basket. For the geometric balloons begin with the triangle pattern at the center and continue outward, again finishing off with the basket. Continue drawing the balloons until the entire surface is covered.

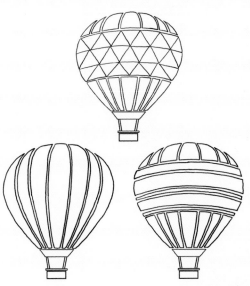

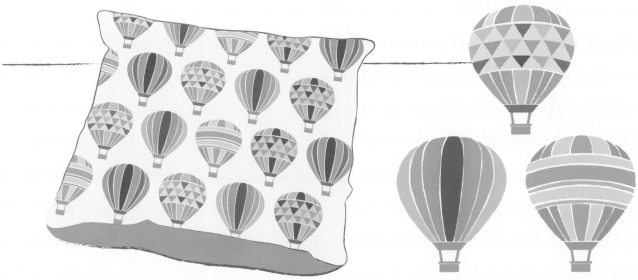

Party Banner

Personalize a party by making your own banner. Cute enough for a kids' birthday, yet modern enough to decorate your daily space.

You will need:

- Colored cardstock
- Cardboard (optional)
- Scissors
- Permanent markers in a variety of colors, including black
- Hole punch
- String, embroidery floss, or ribbon

Skill level:

1 Cut out nine cardstock triangles, making each side 7in (18cm) long. Alternatively, cut out one triangle from a piece of cardboard and use that as a template for cutting all the flags.

2 Choose four flags to draw the figures onto. Use one dark-colored marker to outline the figures, then fill in the outfits with contrasting colors.

3 Each figure drawing starts with a circle for the head. Follow this with the hair or hat, and then the outline of the body.

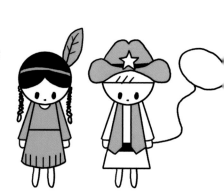

4 Next, draw the arms on the sides of the body and two narrow vertical oval shapes on the bottom of the body for the legs.

5 Finish each figure with the facial features and add the details of their outfits. Let the ink dry completely before adding color to the outfits.

6 Choose three flags to decorate with colorful geometric patterns. Try crosshatches, triangles, circles, or lines.

7 Use the hole punch to punch two holes at the top of each flag. Then cut the string to the required length, allowing extra for the spaces between the flags and to make loops at the ends to hang the banner with.

8 Put the flags in your preferred order. Place a blank flag on the beginning and one on the end. Take your string and loop it through the holes. Alternate between the back and the front of the flags until all flags are strung together.

9 Hang up the banner and party!

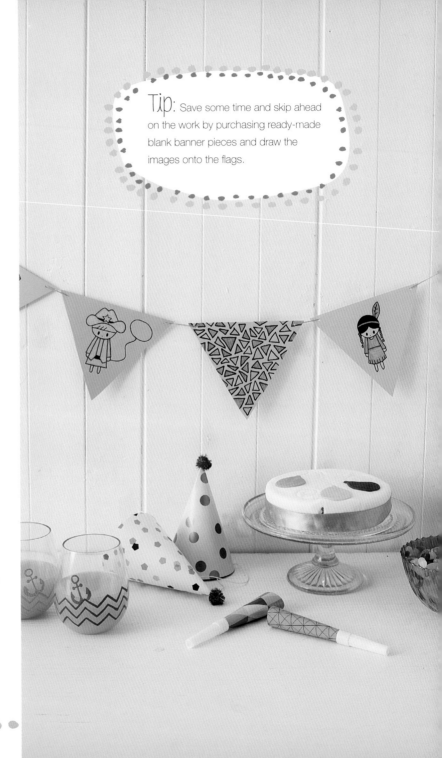

Tip: Save some time and skip ahead on the work by purchasing ready-made blank banner pieces and draw the images onto the flags.

Fashion Floor Cushion

This fashion forward floor cushion is always in vogue. Choose images that suit your style and use permanent markers to create bold outlines and block colors.

You will need:

- White or light-colored plain floor cushion
- Pencil
- Paper
- Sticky tape
- Graphite paper
- Permanent markers in a variety of colors, including gray or black

Skill level:

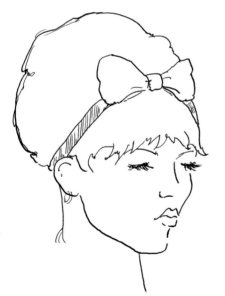

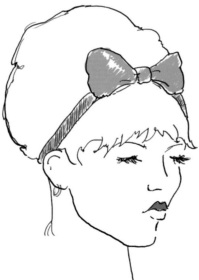

1 Before you begin, test out the permanent markers on the cushion fabric to make sure the ink doesn't run.

2 Find some images that you like—portraits or girls in dresses etc.—then you can either copy the images or trace their outlines with graphite paper, creating a basic shape and adding in any details you like—stripes, bows etc. Keep it simple, following the general outline of the face, jawline, and other facial features before moving onto adding the outlines of the clothes and the rest of the body and finishing off with the accessories.

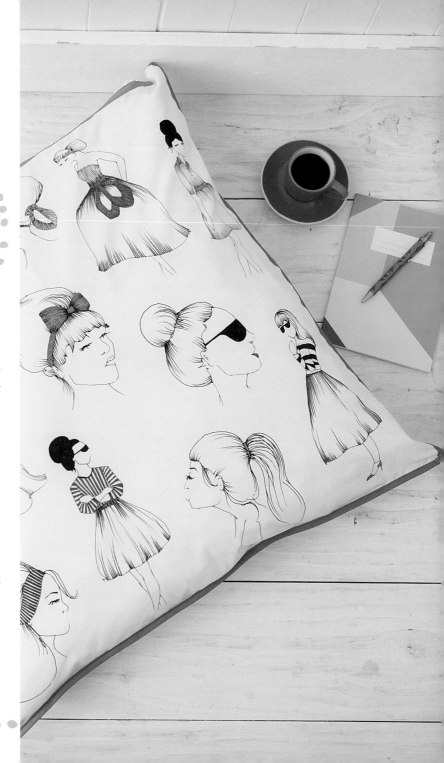

Tip: Trace your design onto your fabric in pencil first so that if you make a mistake, you can correct it. When you're happy with the design, use your pens on top.

3 Roughly cut out all of your drawings, and then cut a separate piece of paper to the same size as your cushion cover and play around with positioning the drawings so that they fit in next to one another. Alternatively, try using one large illustration at the center of the cushion. Once you're happy with your layout, stick them down in place with clear sticky tape.

4 Transfer the design onto the pillowcase using the Graphite paper transfer technique (see page 12). Work in pencil first, and then go over your lines with a gray or black permanent marker. Now have fun filling in your design with color and patterns. Once you are finished, heat-set the fabric using the technique on page 13.

Pear Print Blind

Suggested Sharpie: permanent marker

Use the shapes of the different types and sizes of pears that are available to create this pattern—you could even buy some pears for inspiration. Build up the design gradually using pear motifs of varying dimensions and colors to create a cheerful and colorful pattern that fits together quite neatly.

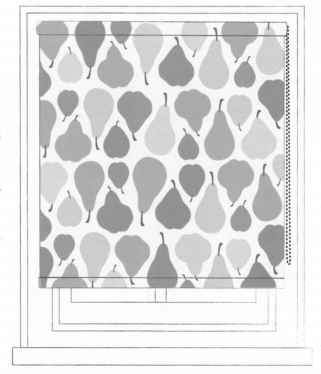

Friendly Face Light Switch

Suggested Sharpie: oil-based paint marker

Use the shapes found within a regular lightswitch to create the features of a face. For example, screw heads could be eyes, or the switch in the center could be a nose. When drawing, build up the facial features gradually, starting with the eyes, mouth, cheeks, and eyebrows, and finishing off with the hair.

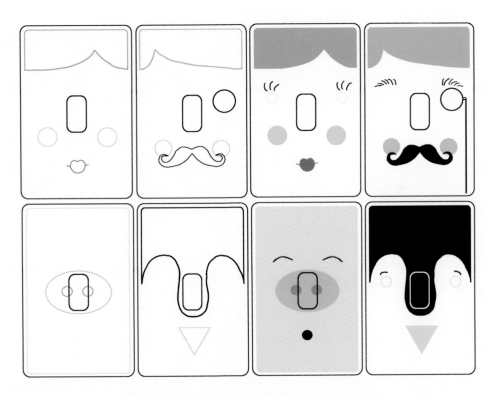

Blossom Paper Fans

Take a simple shape and repeat it in different sizes all over a paper fan to create a blossom-like pattern. This fast and easy design is great for practicing marker skills.

1 Fold out the fan and lay it on a flat surface, such as a tabletop. Carefully flatten out the folds of the fan where you will be drawing onto. Try not to disturb the folds too much and take care not to tear the paper.

2 Start in one corner of the fan and draw the first oval shape. Draw a smaller oval, or a small circle inside it. Keep drawing these in different sizes working downward and across, until you reach the center of the fan.

3 Add some extra details by coloring in some of the ovals, use a second color to color in some of the inner circles, and shade some of the ovals by drawing a few lines through them.

4 If you like, add a few more pieces of blossom scattered around the rest of the fan, as if the wind from the fanning is blowing them away from the group.

5 Carefully refold the fan and put it in your purse, ready to give yourself a little air when needed.

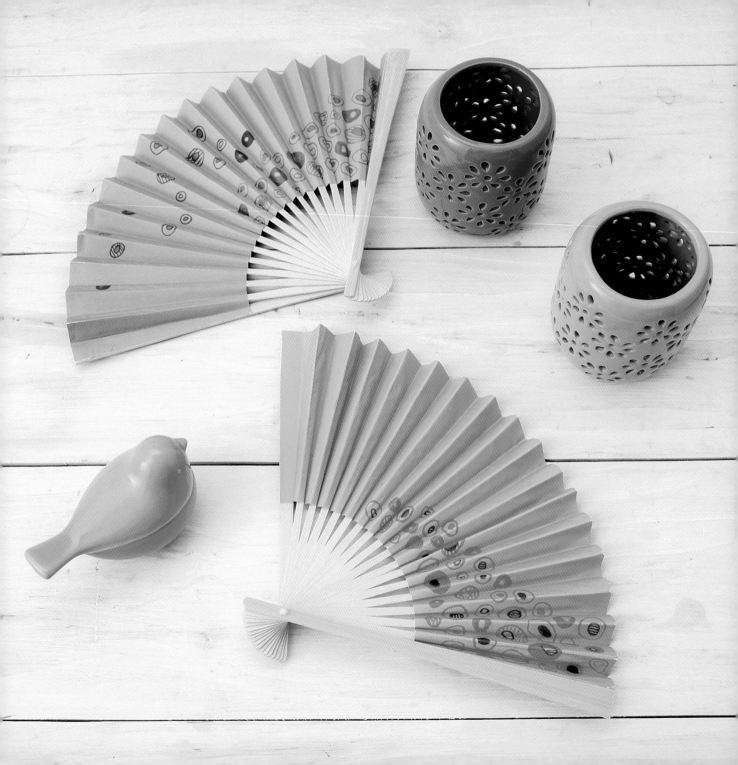

Cacti Phone Case

Tired of looking at your old phone case? It's time to add your own special touch and upgrade! Show off your creative side with your own one-of-a-kind cacti phone case.

You will need:

- Phone case (if using a fabric case, choose a pale base color)
- Rubbing alcohol
- Pencil
- Paper (optional)
- Graphite paper (optional)
- Permanent or oil-based paint markers in a variety of colors
- Sealant (optional)

Skill level:

1. Make sure the case is completely clean. Scrub it, and then wipe it with some rubbing alcohol to make sure it's free of oils and dust.

2. Depending on the material your phone case is made from, you can use permanent markers, or you may need to use oil-based paint markers. Do a test on the inside of the case to check.

3. Decide where you want to put your cacti. If possible, lightly sketch the cacti directly onto the phone case. Alternatively, draw the outlines on paper and transfer the outline to the phone case using the Graphite paper transfer technique (see page 12).

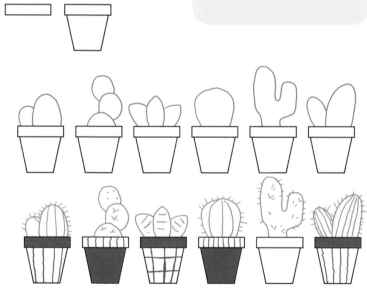

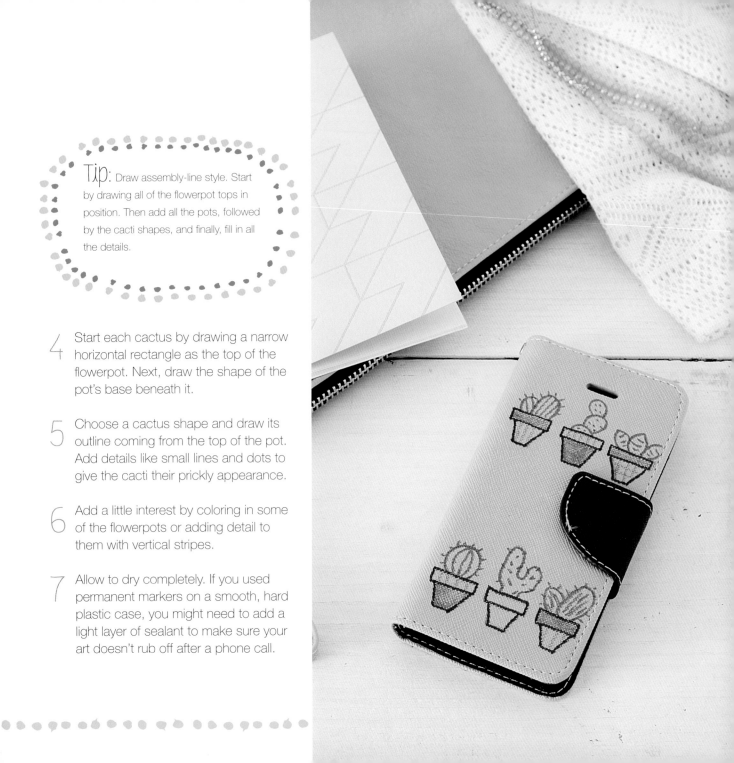

Tip: Draw assembly-line style. Start by drawing all of the flowerpot tops in position. Then add all the pots, followed by the cacti shapes, and finally, fill in all the details.

4 Start each cactus by drawing a narrow horizontal rectangle as the top of the flowerpot. Next, draw the shape of the pot's base beneath it.

5 Choose a cactus shape and draw its outline coming from the top of the pot. Add details like small lines and dots to give the cacti their prickly appearance.

6 Add a little interest by coloring in some of the flowerpots or adding detail to them with vertical stripes.

7 Allow to dry completely. If you used permanent markers on a smooth, hard plastic case, you might need to add a light layer of sealant to make sure your art doesn't rub off after a phone call.

Leafy Scarf

With a couple of markers and some rubbing alcohol, make your own fun and fashionable watercolor tie-dye scarf.

1 First think about the positioning of your circles; in this design the circles are spaced more tightly together on the ends of the scarf and more spaced out toward the middle.

2 Decide where you want to put your first circle, and stretch the scarf over the top of the cup or glass. Pull the fabric taut and put a rubber band around the top of the cup.

3 Using a permanent marker, draw a solid circle inside the rubber band area, approximately half the size of the cup's diameter. Use the Watercolor effect technique (see page 13) to expand the marked circle.

4 Allow the ink to dry before removing the rubber band. Reposition the scarf, and repeat for the rest of the circles. Use a few different markers to vary the circle colors.

You will need:

- Light-colored scarf
- Small cup or glass
- Rubber band
- Permanent markers in a variety of colors
- Rubbing alcohol
- Squeeze bottle or dropper
- Dark-colored fabric marker
- Iron

Skill level:

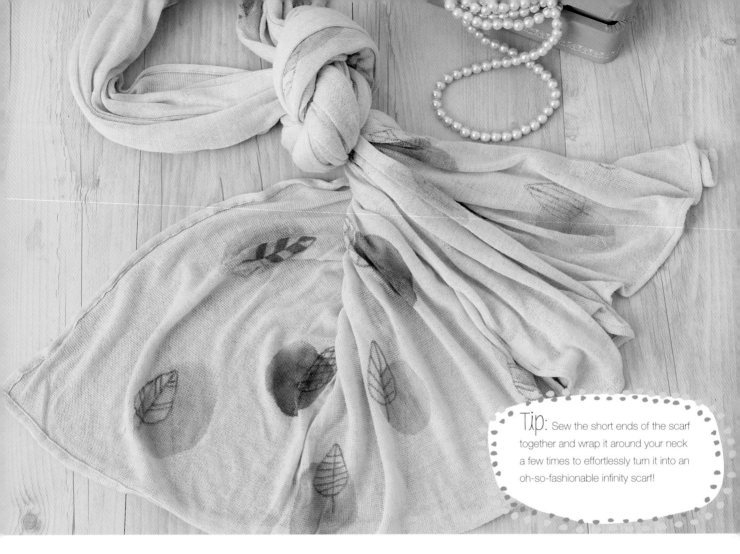

Tip: Sew the short ends of the scarf together and wrap it around your neck a few times to effortlessly turn it into an oh-so-fashionable infinity scarf!

5 Once all of the circles are completely dry, use a dark-colored fabric marker to add a leaf drawing over each of the watercolor circles. For this you could use the leaf designs used on the display bowls on page 124. Offset each leaf somewhat from the center of the circles.

6 Leave to dry and use the Heat-setting fabric technique (see page 13).

Intersecting Scarf

Suggested Sharpie: fabric marker

This design captures the almost three-dimensional quality of parquet tiling on a scarf. To start, it is a good idea to stretch your scarf tightly across a board and secure it with tape to give you a nice flat surface to work on. Choose four colors that complement one another and begin by drawing a parallelogram with a ruler in roughly the center of the scarf. Using the first shape as a starting point, draw further parallelograms of mixed sizes going off in different directions to create a three-dimensional effect. Continue until you have covered the whole scarf.

Why not try the Leafy Scarf project on page 88 for a more whimsical pattern?

Cherry Phone Case

Suggested Sharpie: oil-based paint marker

Start by drawing a nice plump cherry roughly in the center of your phone case. Then, using green, draw in the stem and a leaf. Surround this with more cherries, allowing a little space between, and filling in the stems as you go. Once you are happy with the cherries, fill in the remaining spaces with leaves using a couple of shades of green.

For another idea for decorating a phone case, try the Cacti Phone Case project on page 86.

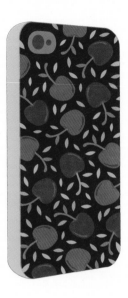
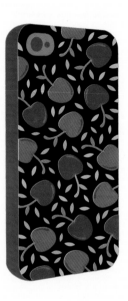

Geo Wallet

For this design you will be decorating a fancy metallic wallet with basic geometric shapes to make it even more luxurious. Two permanent markers and a ruler are all you need for a sophisticated look.

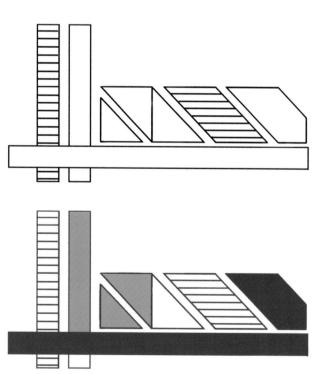

1 Test your permanent markers in an inconspicuous spot to make sure they won't rub off. If they do, use oil-based paint markers instead.

2 Using a ruler, or some painter's tape, mark off a long, thin horizontal rectangle on the bottom of the wallet, the full width from left to right.

3 In the same way, mark two vertical rectangles on the left side of the wallet, so that they appear to go behind the horizontal line.

4 Starting from the point where the lines intersect, draw the outline of a triangle. Next to that, working toward the right, draw the outlines of two elongated diamond shapes. Add a third next to it, cutting off the bottom corner when you reach the right side of the wallet. Now fill in the colors and details.

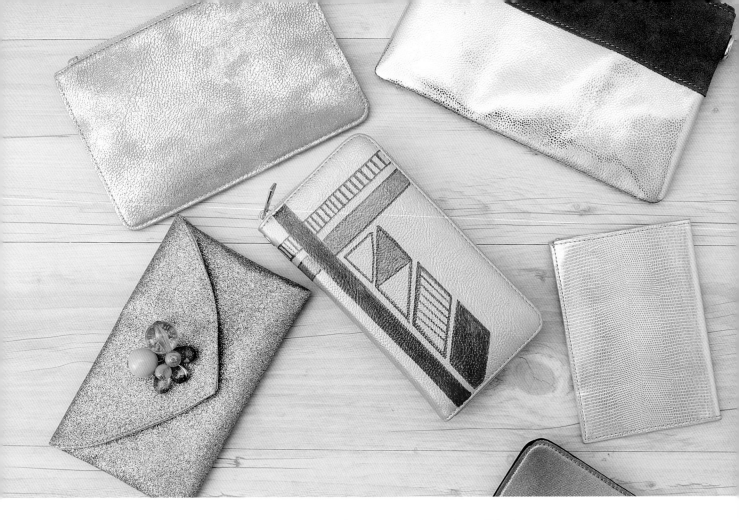

5 Using the base color that you used to draw the lines, color in the horizontal line at the bottom, and the diamond shape furthest on the right.

6 Decorate the vertical line on the left of the wallet and the center diamond with horizontal lines drawn in the same base color.

7 Use a contrasting color to fill in the second vertical line and the left half of the remaining diamond.

Song Bird Headband

Have your head in the clouds and a bird on your head! This is an easy way to freshen up any basic plastic headband with a darling design.

You will need:

- Plastic headband wide enough to draw on
- Pencil
- Paper (optional)
- Graphite paper (optional)
- Permanent markers in a variety of colors
- Sealant

Skill level:

1 If possible, lightly sketch the design directly onto the headband with a pencil. Alternatively, you can draw the design on paper and transfer the outline to the headband later.

2 Draw a circle with a second (partial) circle in it for the bird's head and face. Add a little triangle on the lower left side for the beak.

3 Now for the wing, draw a curving line from the head that swoops down and then up to the right. Make a point for the tip of the wing and then go back and draw three scallop shapes for the lower edge of the wing. Finally, take the line back to the head, a little lower than where you began.

4 Beneath the wing draw two curved lines connecting at their tips, to make the bird's lower breast. Add a small triangular tail where the breast meets the wing.

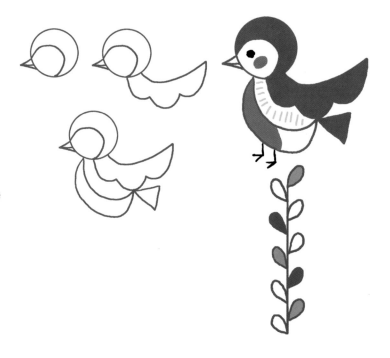

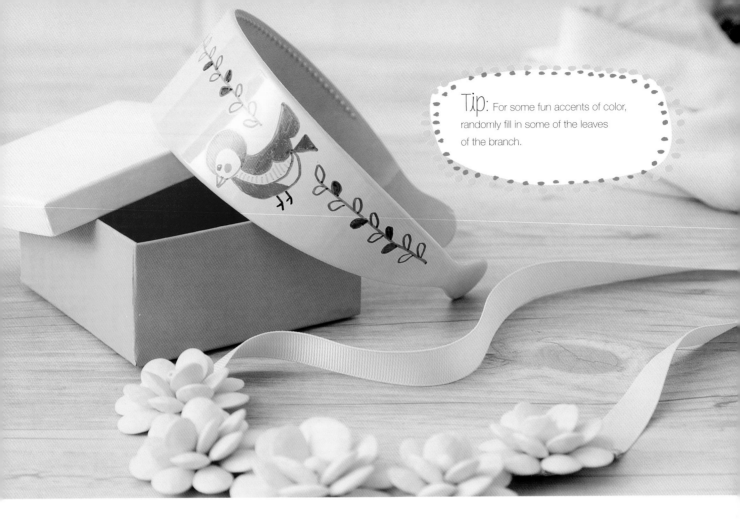

Tip: For some fun accents of color, randomly fill in some of the leaves of the branch.

5 Now transfer the outlines onto the side of the headband using the Graphite paper transfer technique (see page 12). Choose a main color for the bird and go over all of the bird's outlines.

6 Using the same color, fill in the bird's head, wing, and tail. Use a complementary color to fill in the front of the breast. Now add the final details:

Small circles for the eye and cheek, vertical lines on the bird's body, and two legs. Complete the design by adding a branch with leaves the full length of the headband.

7 Allow to dry and add a light layer of sealant to prevent the ink from smudging.

The Street Where You Live Bangles

This project is a great way to get started with Sharpie pens. The simple geometric shapes make it easy to design a pattern to transfer onto the curved surface of the bangles.

You will need:

- Acrylic or plastic bangles
- Pencil
- Permanent markers in a variety of colors including black
- Oil-based paint marker in white
- Sealant

Skill level:

1 Wash the bangles very carefully and leave them to dry. Avoid touching the area to be drawn on after washing.

2 Using a pencil, mark a horizontal line about one-third of the way down from the top of the bangles for the flat-roof height as a guide (the fancy roof shapes are added later).

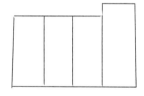

3 Mark the outline shapes on the bangles using the darkest color (black).

4 Now draw in the outlines of the roofs using a mixture of curved and geometric shapes.

5 Mark the windows and doorways onto the buildings.

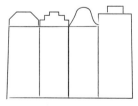

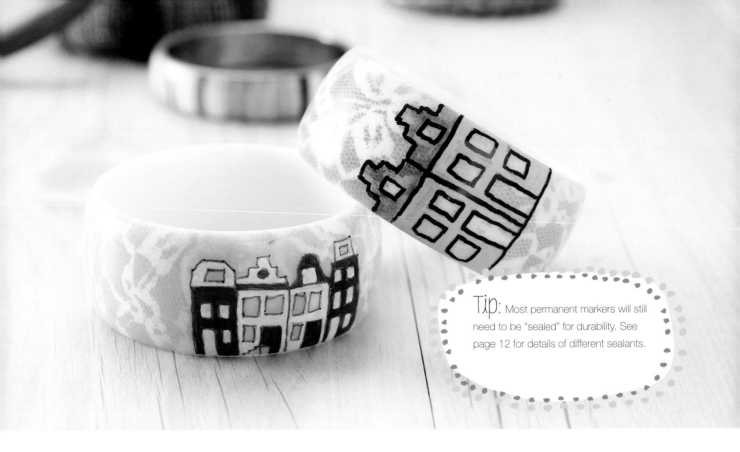

Tip: Most permanent markers will still need to be "sealed" for durability. See page 12 for details of different sealants.

6 Add any additional details such as stairways or streetlamps that you like.

7 Finally, fill in the black shapes and leave the ink to dry for at least one hour, preferably more.

8 Go over the lines of your drawing once more to make sure that there is plenty of ink.

9 Fill in the highlighted areas in white (or the color of your choice), and then leave the bracelets to dry for at least an hour.

10 Go over the lines of your drawing one more time to make sure there is plenty of ink and the lines look strong.

11 Leave the bangles to dry overnight, then add a coat of sealant to protect your design.

Heart Print Sunglasses and Case

This is a very forgiving pattern to draw. The hearts don't have to be in exact positions to work, nor do they all have to be perfectly symmetrical or the same size.

You will need:

- Plastic sunglasses
- Hard sunglasses case
- Rubbing alcohol
- Pencil (optional)
- Oil-based paint markers in a variety of colors

Skill level:

1 First, clean the sunglasses; make sure they're completely clean and wipe them with rubbing alcohol to remove oils and dust.

2 Choose your color palette and draw some little hearts scattered on the arms of the glasses. Add some dots in-between the hearts. Add some dots to the front of the glasses as well.

3 The case is decorated with a mod-style girl's face. Sketch her in pencil first, or use markers straight away. Start with a circle for the face. A horizontal line halfway down gives the girl her bangs.

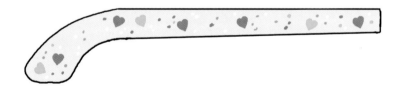

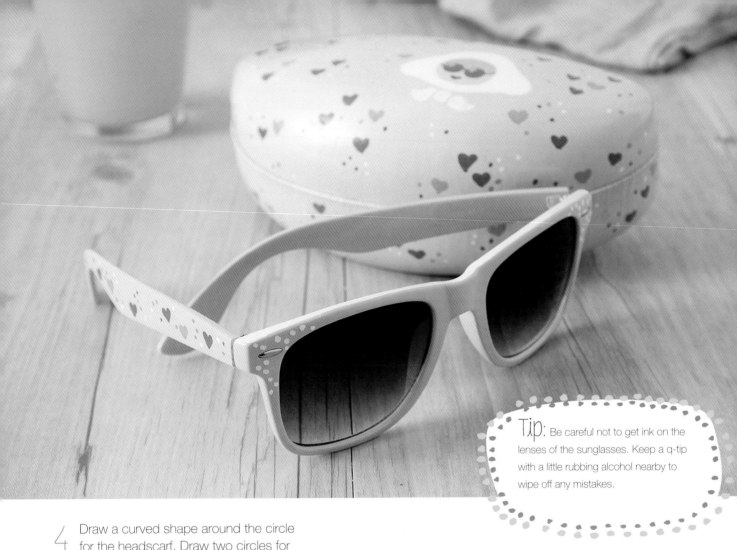

Tip: Be careful not to get ink on the lenses of the sunglasses. Keep a q-tip with a little rubbing alcohol nearby to wipe off any mistakes.

4 Draw a curved shape around the circle for the headscarf. Draw two circles for the lenses of her sunglasses and add lines for the bridge and arms.

5 Two small white curves on the lenses give the glasses a shiny reflective effect. Finish her face with a heart shape for the mouth and a bow on the bottom of her scarf.

6 Cover the rest of the case in small hearts and dots.

Peacock Clutch Purse

Pretty as a peacock! Two peacocks make this purse, just the thing to finish off that perfect outfit for a night on the town.

You will need:
- Clutch purse
- Paper
- Pencil (optional)
- Graphite paper (optional)
- Oil-based paint markers in a variety of colors

Skill level:

1 If possible, you could lightly sketch the design directly onto the purse. Alternatively, draw the design on paper and transfer to the clutch later.

2 Start by drawing the outline of the peacock's head and body. Begin with the head, moving along to the neck and then the body.

3 With the body outlined, move onto the tail and head feathers. First draw the pointed oval shapes, and add the spirals on both sides.

4 Transfer the outline image onto the purse using the Graphite paper transfer technique (see page 12). Using an oil-based paint marker, go over all the outlines of the peacock and the tail and head feathers.

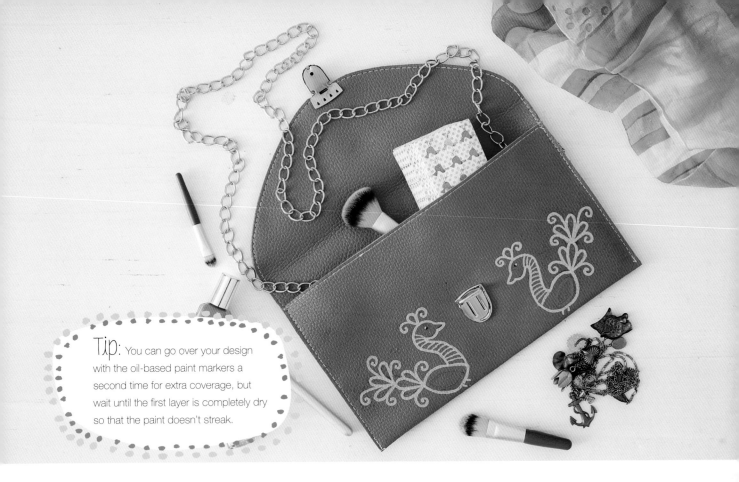

Tip: You can go over your design with the oil-based paint markers a second time for extra coverage, but wait until the first layer is completely dry so that the paint doesn't streak.

5 Using the same marker as used for the outlines, add horizontal stripes all over the neck of the peacock. On the bottom of the body, draw two short lines for the legs.

6 Let the paint dry before moving onto the secondary color for the detailing. Add color between the lines on the neck, and draw the outline of a wing on the body. Two little dots go in each of the ovals on the tail feathers.

7 Finally, add a circle on the head to make the eye. Let the paint dry and put a black dot in the middle. Once this is dry, add a white dot slightly off-center.

8 Reverse the picture so that you have a mirror image and draw another peacock on the other side of the purse.

Beaded Necklace

So fancy! Create a one-of-a-kind, personalized piece of statement jewelry from a plain plastic beaded necklace. The perfect way to color match your favorite outfit.

You will need:
- Chunky plastic beaded necklace
- Permanent markers in two colors
- Sealant

Skill level:

1 For this freeform project there is no need to sketch and transfer. Just draw directly onto the beads of the necklace with the permanent markers.

2 Play around with drawing a variety of different shapes on the beads. Color one half of some beads; draw lines across them; fill some with small triangles; and leave some of the beads as they are.

3 While working, try to hold the necklace at the bead next to the one you are working on, or, using your fingertips, hold the area of the bead that's not being inked. Avoid touching the ink too much, as it will smudge.

4 Leave the necklace to dry for about 24 hours. The ink might still smudge a little (certain colors smudge more than others), but it will not smudge as much as when just drawn on.

5 A layer of sealant is needed for the colors to last. Find a place where the necklace can hang without touching anything and carefully brush sealant onto the inked areas. Leave to hang and dry completely for 24 hours.

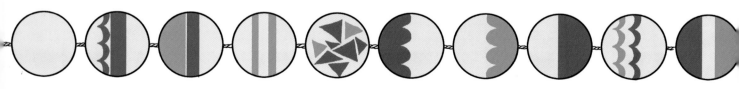

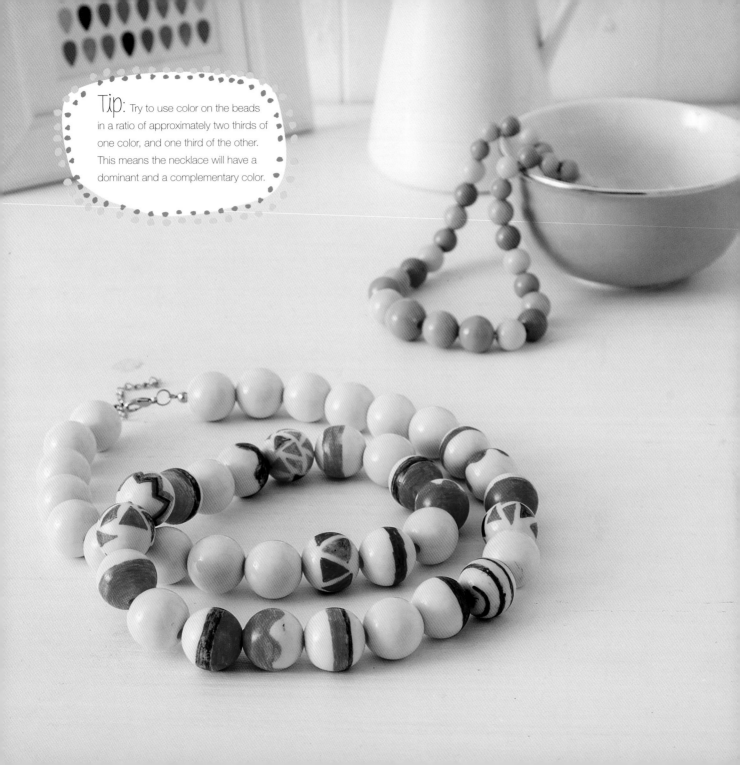

Tip: Try to use color on the beads in a ratio of approximately two thirds of one color, and one third of the other. This means the necklace will have a dominant and a complementary color.

Roses Tattoo T-Shirt

These projects are fantastically zen-like to draw. Simply find a pretty outline (here, a rose shape) and then fill the petals with varying patterns such as polka dots and crosshatches. Your T-shirt is now a work of art!

You will need:

- T-shirt
- Permanent markers in a variety of colors, including black
- Cardboard
- Sticky tape
- Bulldog clips
- Embroidery hoop
- Pencil (optional)
- Graphite paper (optional)
- Iron
- Clear fabric paint

Skill level:

1 Wash and dry the T-shirt (even if new).

2 Draw your outline using the black permanent marker on a piece of paper. On many T-shirts, you will be able to see this design through the fabric, and you can simply trace over the design onto the fabric. Place the paper outline over a piece of cardboard and tape in place. Wrap the T-shirt over this, right side out. Hold in place over the design with several bulldog clips.

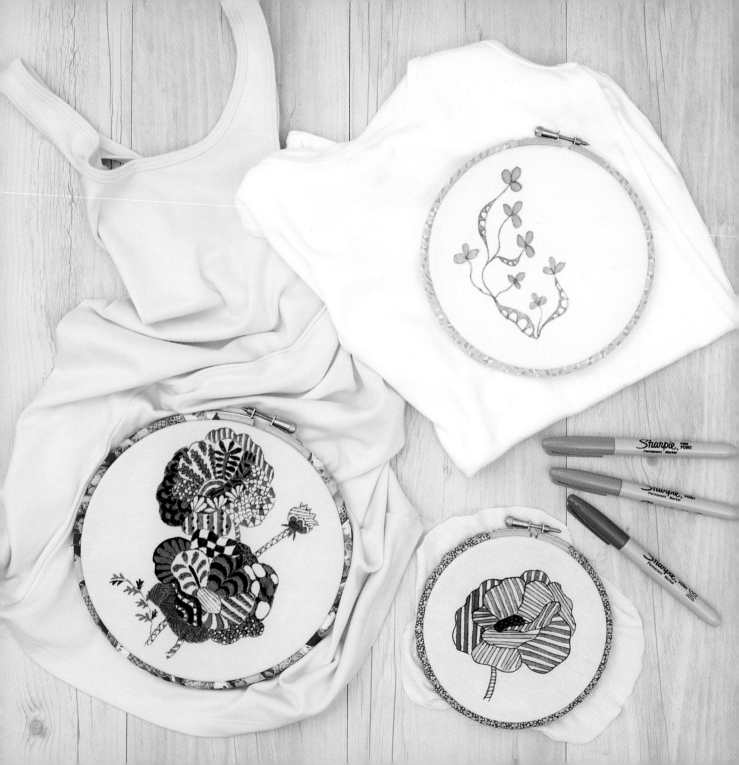

3 Alternatively, on thicker fabrics, transfer the design onto the T-shirt using the Graphite paper transfer technique (see page 12). Secure the fabric to a surface or sheet of cardboard using bulldog clips; or use an embroidery hoop to reduce distortion while drawing the design.

4 Put a sheet of cardboard or plastic between the T-shirt and the surface to prevent staining. Begin to fill in the areas of doodle color patterns using the pattern ideas shown on this page as a guide. Try and add a different pattern or color to each petal.

5 Once complete, leave the fabric to dry overnight, then iron on the reverse to set the design. Paint over the design using clear fabric paint and once it's dry, follow the Heat-setting fabric designs technique (see page 13).

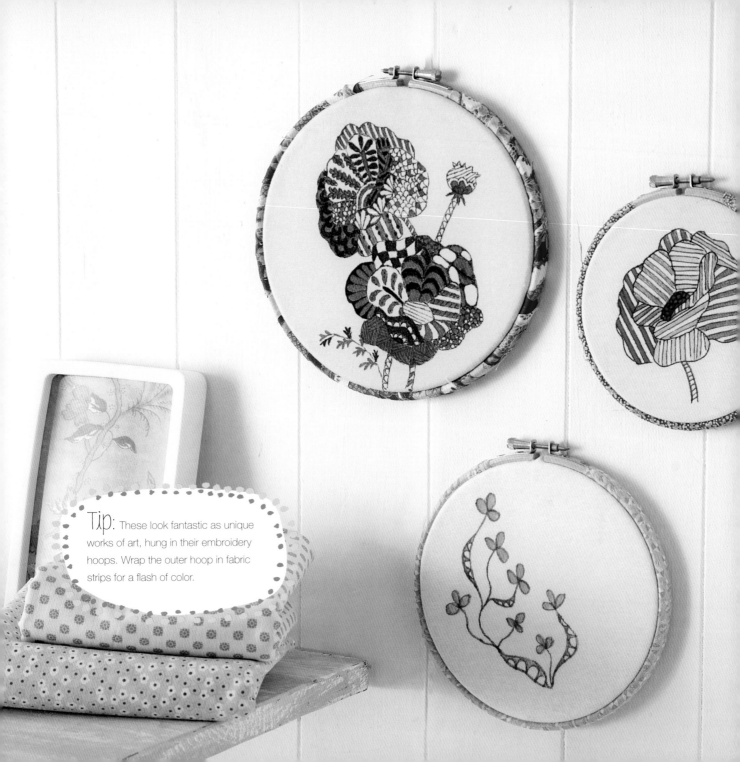

Tip: These look fantastic as unique works of art, hung in their embroidery hoops. Wrap the outer hoop in fabric strips for a flash of color.

Cacti Tote Bag

This is a great project to get you started with Sharpie pens; taking an inexpensive tote bag and turning it into a fun and unique accessory. It would make a great gift for a friend.

You will need:

- Plain canvas tote bag
- Iron
- Paper
- Pencil
- Permanent markers including neon and metallic colors

Skill level:

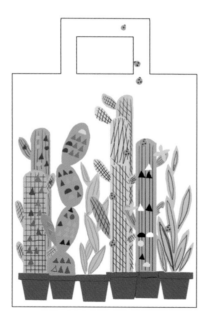

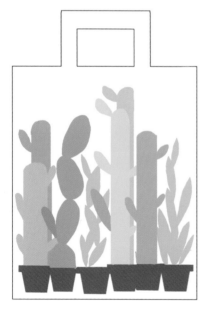

1 Iron the tote bag so that it's crease-free and flat. You can then roughly sketch out the cacti onto the tote, so that you have a guide as to how big the illustration will be.

2 Place old newspaper or sheets of paper inside the tote bag so that when you start coloring in with the pens it doesn't bleed through to the other side of the bag.

3 Start coloring in the cacti. It's a good idea to practice coloring on paper beforehand; try out different strokes and techniques to find a method that works well for you.

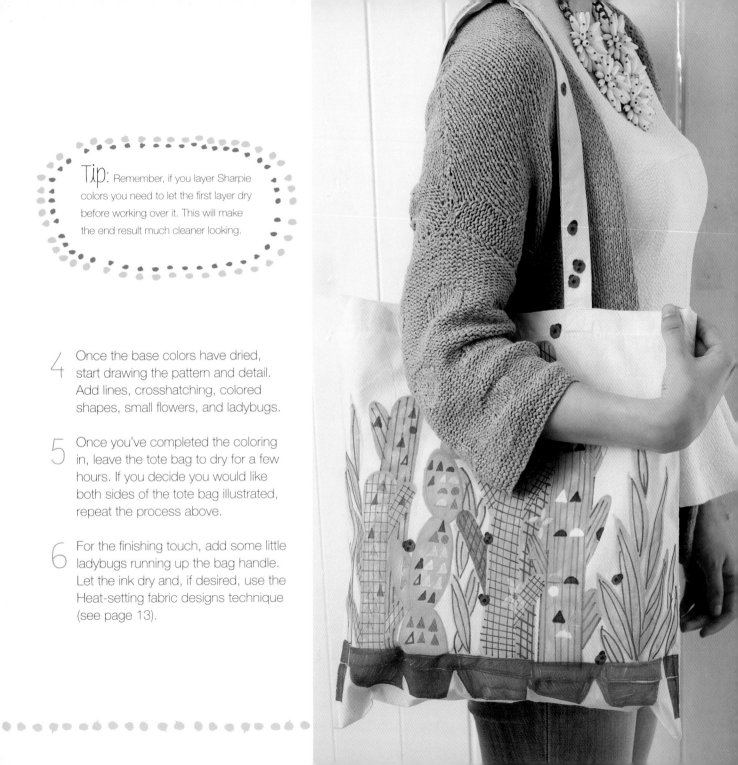

Tip: Remember, if you layer Sharpie colors you need to let the first layer dry before working over it. This will make the end result much cleaner looking.

4 Once the base colors have dried, start drawing the pattern and detail. Add lines, crosshatching, colored shapes, small flowers, and ladybugs.

5 Once you've completed the coloring in, leave the tote bag to dry for a few hours. If you decide you would like both sides of the tote bag illustrated, repeat the process above.

6 For the finishing touch, add some little ladybugs running up the bag handle. Let the ink dry and, if desired, use the Heat-setting fabric designs technique (see page 13).

Cityscape Shoes

A great project for when you are dreaming about your next vacation: Add some scenery to a pair of basic canvas shoes and make a fabulous accessory for any outfit.

You will need:

- Plain white canvas shoes
- Pencil
- Eraser
- Permanent markers in a range of colors
- Transparent fabric paint (optional)

Skill level:

1 Roughly visualize your design by using a pencil to lightly sketch onto the shoes. You can use an eraser to rub out any errors or unwanted lines.

2 The design is created by layering colors on top of one another, so start by deciding which colors you would like for the base layer of the houses and color block these in first.

3 Once you have done this, leave the shoes to dry for a half a day because the marker pen inks tend to absorb into the canvas material very quickly and bleed quite a bit.

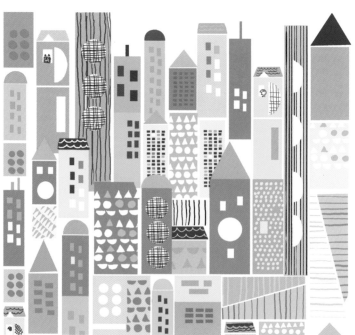

4 Once the background color blocking has dried, draw in the details of the houses with a different colored permanent marker, adding the smaller details on top. There are no strict rules on how to do this for this design, but you can use the images here to refer to while decorating the shoes.

5 Layer on more colors and details until the design is full. Once you think the illustration is finished, leave the shoes to dry in a cool, dry place for a few hours and then use the Heat-setting fabric technique (see page 13). Alternatively, try coating the shoes in a layer of transparent fabric paint.

Tip: This project is really fun to work on with a friend; draw on one shoe each!

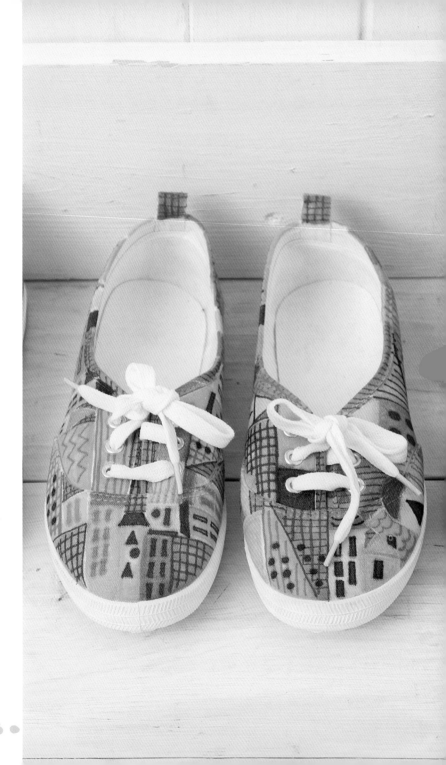

Nautical Picnic Tumblers

Fun ahoy! These bright, disposable tumblers are a great addition to any summer picnic basket. Fill with a drink of your choice and see the anchors float happily on top of an ocean of juice.

You will need:

- Clear plastic tumblers
- Pencil
- Paper
- Sticky tape
- Oil-based paint markers in a variety of colors
- Sealant

Skill level:

1 Start by drawing the anchor and three lines of zigzags on a piece of paper. Use sticky tape to position the sketch inside the cup as a template. Make sure the design is facing out through the cup.

2 Using an oil-based paint marker, trace the anchor onto the cup. Once dry, use a second paint marker and go over all the zigzags.

3 Leave to dry completely and for extra protection, paint the design with a light layer of sealant.

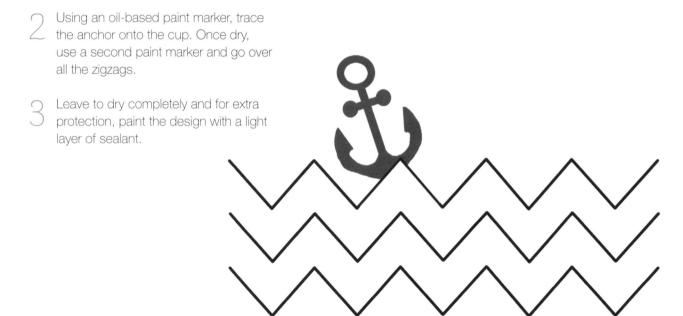

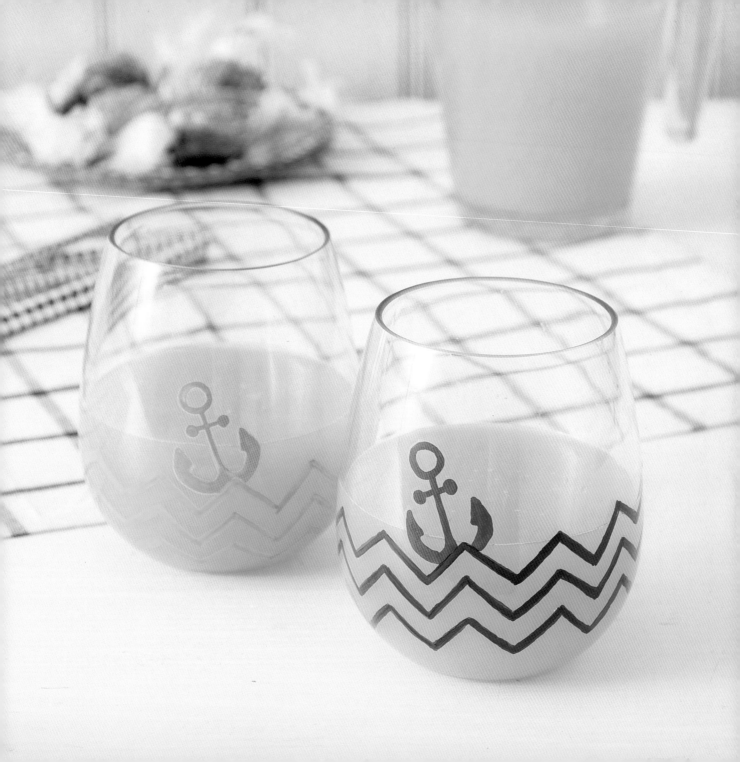

Figure Eight Place Mats

Are you a true foodie? Enjoy different cuisines from all over the world? Take it to the next level with these fun place mats.

You will need:

- Place mat
- Pencil
- Paper (optional)
- Graphite paper (optional)
- Permanent or oil-based paint markers in three colors, including white

Skill level:

1 Place your favorite plate on the center of the mat, and measure the visible areas on the left and the right. These spaces will be the areas you will draw on.

2 Measure out a drawing of the visible areas on a piece of paper; you will use this to sketch the design onto before transferring it to the place mat. You can skip this step if you are brave enough to sketch the designs directly onto the place mat.

3 Using the pencil, start by working out the positioning of the long, vertical oval outlines. Next, draw the circle outlines on top of and around the ovals. The left and right sides of the place mat designs will be mirror images, so keep this in

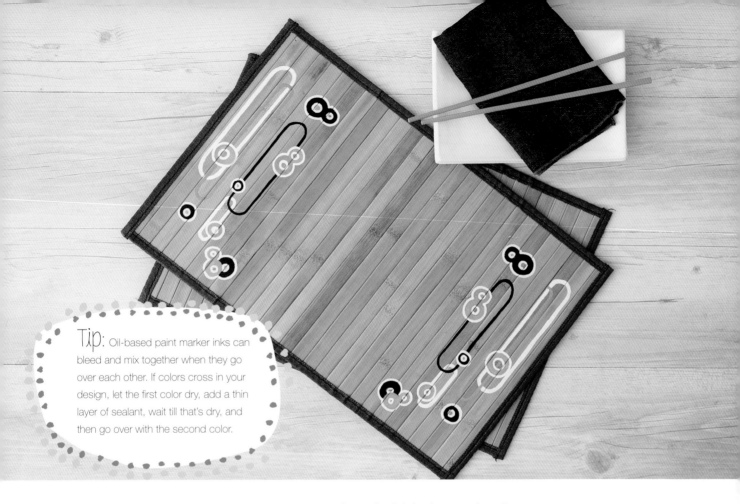

Tip: Oil-based paint marker inks can bleed and mix together when they go over each other. If colors cross in your design, let the first color dry, add a thin layer of sealant, wait till that's dry, and then go over with the second color.

mind when positioning the outlines. If you sketched the outlines on paper first, now is the time to use the Graphite paper transfer technique (see page 12).

4 Using the oil-based paint markers, start going over the circles first, outlining them with white. Wait until the ink has dried and consider adding a sealant before moving on.

5 Once the ink is dry, use the other colors to fill in the circle outlines then go over the oval lines.

6 Depending on the color and material of the place mat used, you might need to go over the design again to get it as opaque as possible. Again, start with the circles and move on to the oval shapes.

Diamond Design

Transform ordinary bud vases into eye-catching design pieces with this diamond pattern. Add a striking geometric pattern onto each of the vases and then make a gift box to match!

You will need:

- Glass bud vases
- Scissors
- Cardstock
- Pencil
- Oil-based paint markers in two colors

Skill level:

1 Cut a diamond shape from the cardstock to use as a template.

2 Position the template on the bud vase and lightly draw around it with a pencil. Move the template to the next position, and again draw lightly around it. Continue doing so until the entire pattern is penciled onto the surface.

3 Draw over the lines with the oil-based paint markers and fill in the shapes. Add an extra pop of color to the pattern by using a second color to outline and fill one or two of the diamond shapes.

4 Allow to dry completely. For extra protection, use the Heat-setting glassware technique (see page 14).

Tip: Switch your designs: this diamond pattern works well on glass votive candle holders (page 120), and the mod flowers work well painted upside-down on a bud vase (see page 121).

Aztec Feather Vase

Suggested Sharpie: oil-based paint marker

Start illustrating the first feather on the vase by drawing the stem. Then mark in the shapes at the tip, and the bolder blocks between the stem and tip until you have the general outline shape of a feather. Now begin to fill in the solid blocks of color and build up the detail in layers—start with the lightest colors, and then move on to the darker shades. Work around the vase, evenly spacing the feathers. If you find this process difficult, position feather number one at 12 o'clock, and draw the second at 6 o'clock, third at 3 o'clock, fourth at 9 o'clock, and so on.

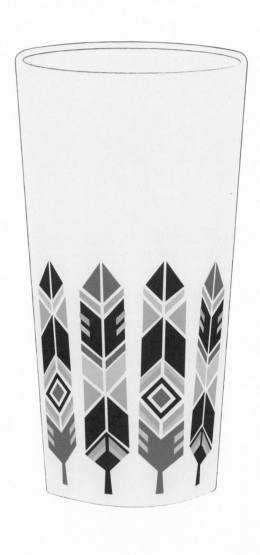

Popsicle Wooden Tray

Suggested Sharpie: oil-based paint marker

Using a pencil and an upturned side plate, mark the baseline for each popsicle stick. Use the idea of a clock face to ensure that they are evenly spaced; starting at the 12 o'clock on the plate, then 6 o'clock, 3 o'clock etc., then fill the spaces in-between. Start by drawing the popsicle sticks and then move on to the popsicles themselves, alternating through your chosen colors and styles of popsicle as you work, so that you don't have the same popsicles next to one another.

See the Summery Storage Box project on page 56 for more ideas on decorating with ice cream motifs.

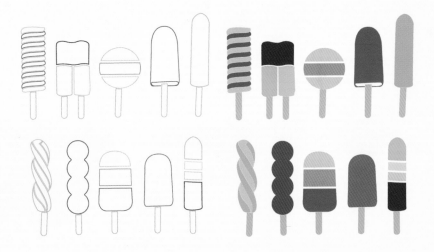

Daisy Motifs

Glass is a remarkably easy surface to draw onto with an oil-based paint marker. These half daisies are a quick and delightful way to add a little extra personality to your home décor—try a votive holder or a tiny bud vase.

You will need:
- Glass votive candle holders
- Paper
- Pencil
- Sticky tape
- Oil-based paint markers in two colors

Skill level:

1 Draw the half daisy design on a piece of paper sized to the circumference of the exterior edge of the votive holder.

2 Using sticky tape, attach the design to the inside top edge of the votive holder with the design showing on the outside.

3 Trace the design with a pencil first, or directly outline it with the oil-based paint markers.

4 Start with the half circle centered at the top. Then, using a second color, draw another half circle around the first circle, leaving a little space in-between them.

5 For the flower petals, use the first color again, and draw four, almost full, circles around the half circles. Decorate the flower with a few scattered dots.

6 Allow the paint to dry. For extra protection, use the Heat-setting glassware technique (see page 14).

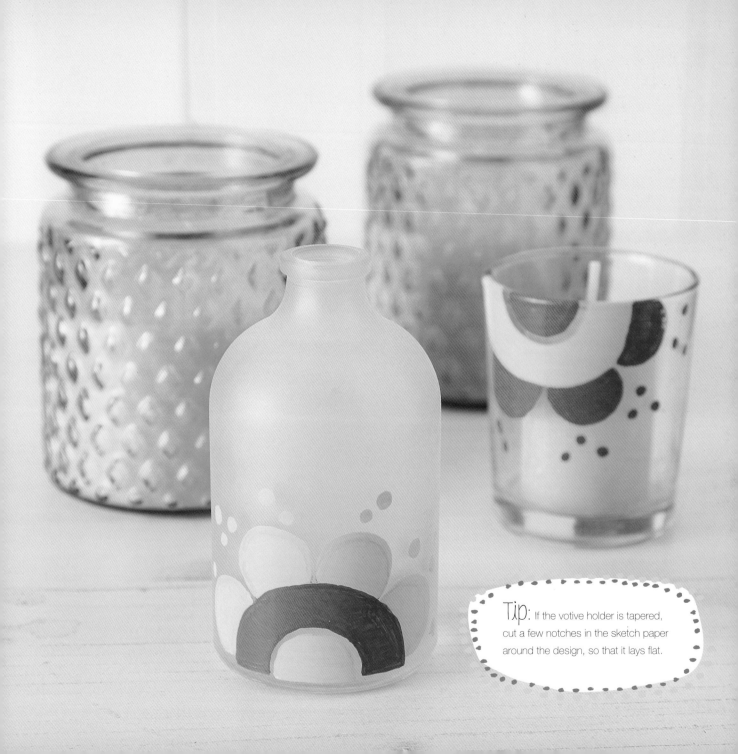

Tip: If the votive holder is tapered, cut a few notches in the sketch paper around the design, so that it lays flat.

Kitty Cups

Children and adults alike will love these quirky little cups. This is a great project to get children involved with too: if you draw the outlines, little ones will be able to help fill in the colors.

You will need:

- Glazed ceramic mugs and cups
- Oil-based paint markers
- Sealant

Skill level:

1 First draw the outline shapes onto the mugs. Make the outline of the cat shape one triangle at a time, then add the facial stripe, tail, feet, ears, eyes, and whiskers. Leave to dry each time.

2 Fill the areas of color, one at a time, starting with the red, then adding the yellows, allowing the ink to dry between applications.

3 Leave the cups to dry overnight, then bake them following the Heat-setting ceramics technique (see page 14). Heat the cups twice for the best results. Once completely cool, seal the cups using sealant.

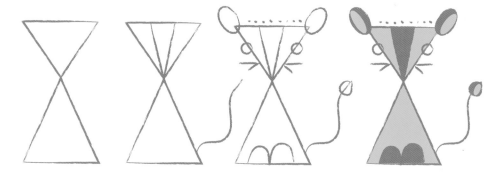

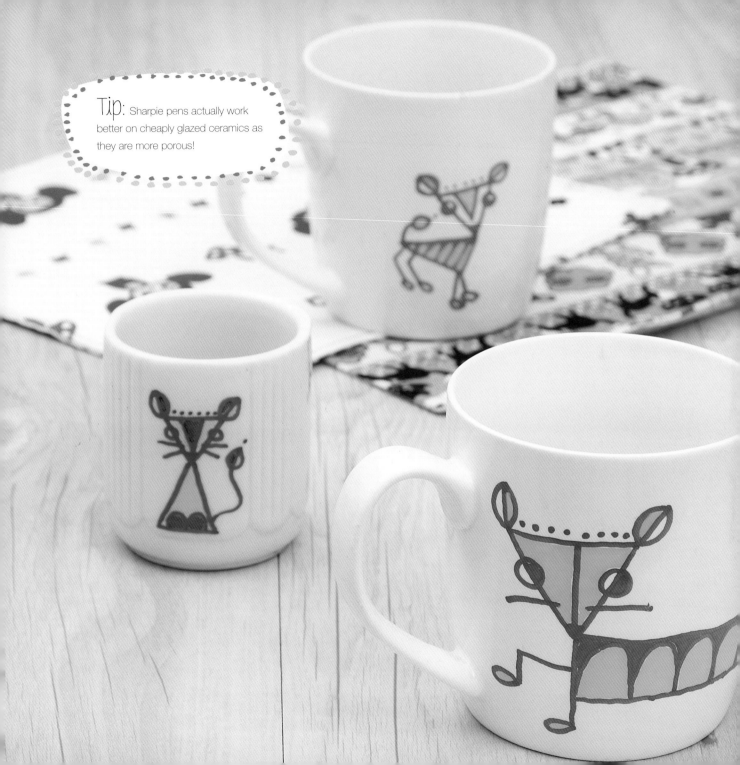

Tip: Sharpie pens actually work better on cheaply glazed ceramics as they are more porous!

Tricolor Display Bowls

Give a plain cereal bowl a striking makeover as a useful dish. Choose between two variations of these modern leaf designs.

You will need:

- White ceramic cereal bowl
- Pencil
- Paper (optional)
- Graphite paper (optional)
- Oil-based paint markers in four colors

Skill level:

1 If possible, lightly sketch the design directly onto the bowl. Alternatively, you can draw the design onto paper and transfer the outline to the bowl later.

2 To start a leaf, draw a vertical line for the center vein and stem. Next, draw the leaf shape, and add detail lines on a few of the leaves. Draw a dividing line in-between each leaf.

3 Transfer the outlines onto the bowl using the Graphite paper transfer technique (see page 12). When transferring onto a rounded surface like a bowl, a long, straight sketch won't lay completely flat. To help make the design more even and straight, either draw the sketch out at a slightly curved angle, cut some notches in the paper around the design, or cut the sketch up into smaller pieces so that you can transfer shapes individually.

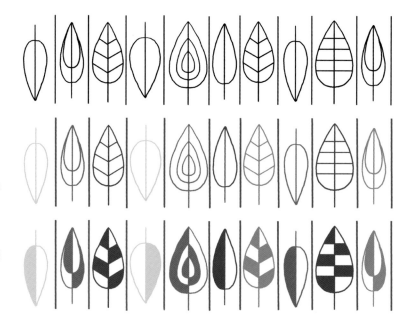

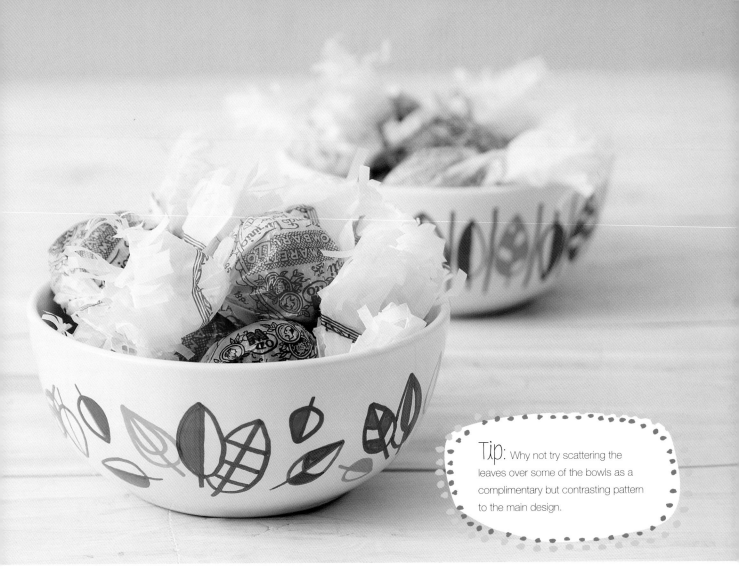

Tip: Why not try scattering the leaves over some of the bowls as a complimentary but contrasting pattern to the main design.

4 Go over the outlines of the sketch with the oil-based paint markers. Use one color for the dividing lines, and alternate the colors of the leaves. Let each color dry before moving on to the next.

5 Finish the design by adding some solid color-filled blocks inside the leaves.

6 Leave the paint to dry. For extra protection, use the Heat-setting ceramics technique (see page 13).

Skyline Fruit Bowl

A large, white ceramic fruit bowl is a great base for a cityscape surround drawing. The finished item makes a fabulous centerpiece for any dinner table or kitchen counter.

You will need:
- White ceramic serving/ fruit bowl
- Pencil
- Paper (optional)
- Graphite paper (optional)
- Oil-based paint markers in a variety of colors
- Sealant (optional)

Skill level:

1 Draw the design on paper to transfer to the bowl later. Or, alternatively, sketch the design directly onto the bowl.

2 First, draw a horizon line. Next, draw the buildings. Divide them into three sections by leaving some space in-between them. Add the roofs, doors, sign boards, and windows.

3 Draw a tree in-between the first two sections of buildings. Start with the trunk, then four concentric ovals for the foliage.

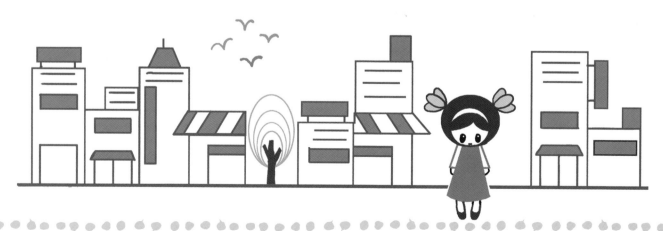

4 Draw the figure of the girl in-between the second and third sections of buildings. Start with two circles inside each other for the face and hair. Add her dress, arms, and legs next. Finish with the flowers on her head and draw the headband, bangs, and facial features.

5 A long sketch for a round item is difficult to transfer as one piece as it will not lay flat; to solve this problem, cut the sketch into three pieces, cutting in-between the sections of buildings.

6 Transfer each section of the design onto the bowl using the Graphite paper transfer technique (see page 12). Drawing the horizon line onto the bowl first can help to align the sections.

7 Using a dark-colored oil-based paint marker (purple here), trace all the buildings' outlines first. When the paint is dry, fill the color blocks.

8 Color the girl and the tree. Finish with the birds in the sky, and add detail lines to the buildings.

9 Let all paint dry completely. For extra protection, add a light layer of sealant to the design, or use the Heat-setting ceramics technique (see page 13).

Floral Fruit Bowl

Suggested Sharpie: oil-based paint marker

Choose three tones of one color that will make up the petals of your feature flowers—pinks work really well. Begin by drawing each flower, starting with the petals and then adding the stems. Try rotating the flowers and playing with scale for a really dynamic effect. Draw in the lime green blooms in the larger spaces between the pink flowers. Start with the center petals and work your way out to create circular blooms. Fill in the background space surrounding the flowers with a light color to finish off.

For an alternative way to decorate a fruit bowl, see the Skyline Fruit Bowl project on page 126.

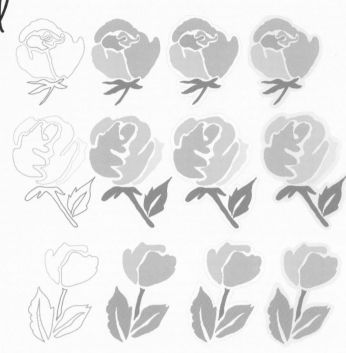

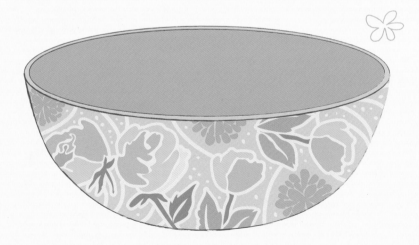

Chili Pepper Apron

Suggested Sharpie: fabric marker

Fold your apron in half lengthwise and start by drawing a row of bright red chiles along the center fold. Then unfold the apron and draw the mirror image of these down the other side of the fold. Use the first rows as a guide to draw the second rows either side of the original two rows, and add the green stems for the finishing touch.

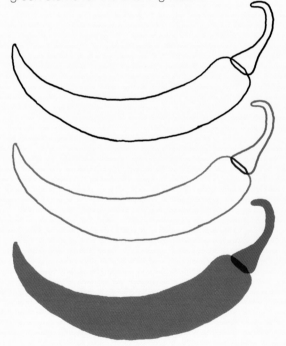

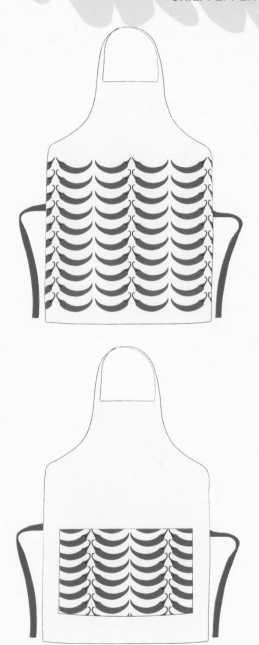

Pretty Birdhouse

There is no reason for a bird to live in a boring house; it just needs a little help decorating. Drawing some vintage-inspired flowers on the walls is exactly what turns a birdhouse into a bird home.

You will need:
- Wooden birdhouse
- Acrylic paint
- Paintbrush
- Permanent or oil-based paint markers
- Sealant (optional)

Skill level:

1 Using acrylic paint, apply a base color to the birdhouse. Use white for the walls, green on the bottom to mimic grass, and light blue on the roof to give an airy feel.

2 The backgrounds for the flowers are large circles of solid ink. Using bright colors, draw the circles on the front and sides. They don't have to be perfect in shape; keep it playful.

3 Now draw in the flower details. Using a pen shade darker than the background color, fill the flower circles with patterns of stripes, circles, and dots. Start in the center of each flower, and work outward. Finish by adding petals around the outside of the base circle.

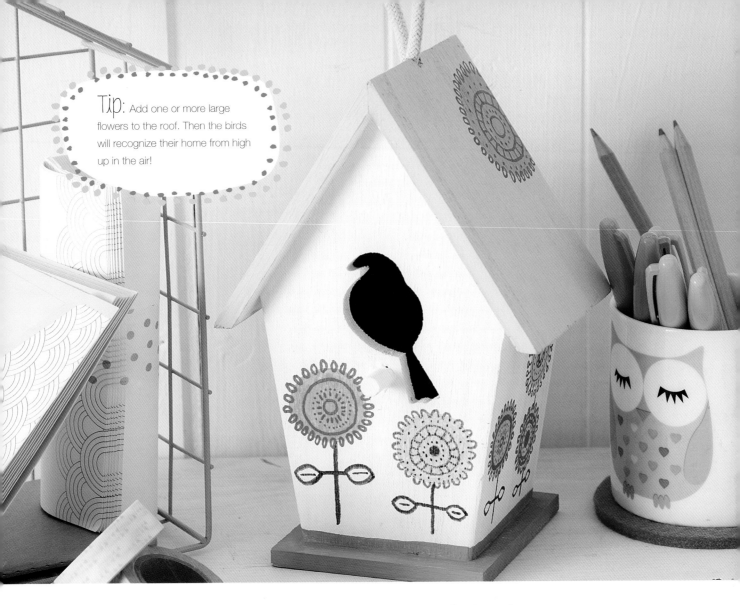

Tip: Add one or more large flowers to the roof. Then the birds will recognize their home from high up in the air!

4 Add a long vertical line beneath each flower and draw a shorter horizontal line across the vertical line. Add leaves to either end of the horizontal line.

5 The ink won't rub off with regular handling, but if you plan to hang the birdhouse in your garden, a layer of sealant is recommended (see page 12).

Treetop Chair

Make a plain chair homely by decorating it with tree and house icons! Choose colors that match your home décor and it will become the centerpiece of the room.

You will need

- Chair
- Pencil
- Paper
- Sticky tape or adhesive putty
- Graphite paper
- Permanent markers in a variety of colors
- Sealant (optional)

Skill level:

1 Sketch your design freehand or create the template for your design digitally. When you are happy with the pattern, print and cut out all of the different elements.

2 Attach sticky tape or adhesive putty to the top of the templates to fix them to the chair. You may need to move them around a bit in order to find the right composition.

3 When you are happy with the composition, transfer the design onto the chair using the Graphite paper transfer technique (see page 12).

4 Once you have added the full design to the chair, color in the different designs.

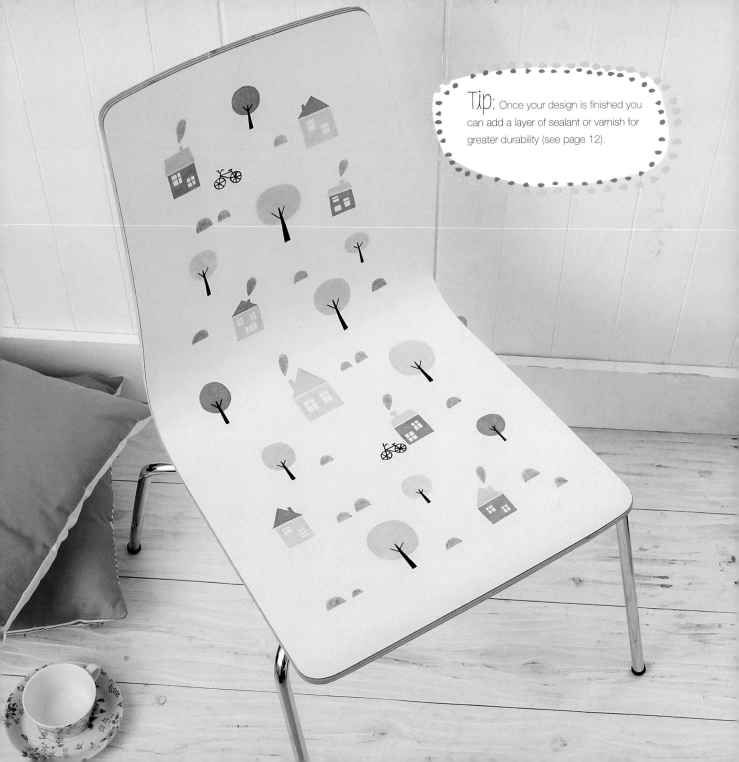

Tip: Once your design is finished you can add a layer of sealant or varnish for greater durability (see page 12).

Whimsical Shelves

Decorate your wall with these functional yet beautiful shelves and bring a splash of color and fun to your home.

1 Wipe the surface of the shelves with a wet cloth to ensure they're clean.

2 Select your marker pen colors: Four per shelf for this project.

3 Using the templates provided as a guide, lightly sketch out the design you like onto the shelves. Use a pencil for this step so that it can easily be erased should you make an error.

4 Build up the design gradually using the different design elements: Start in one corner with the small shapes and make them larger as they cross the shelf.

5 Now it's time to fill in the design elements with color—allow the ink to dry between motifs to avoid smudging.

6 Gradually fill all pencil marks with color and build up your design; allow the ink to dry before mounting the shelves as per the manufacturer's instructions. Add a layer of sealant for greater durability.

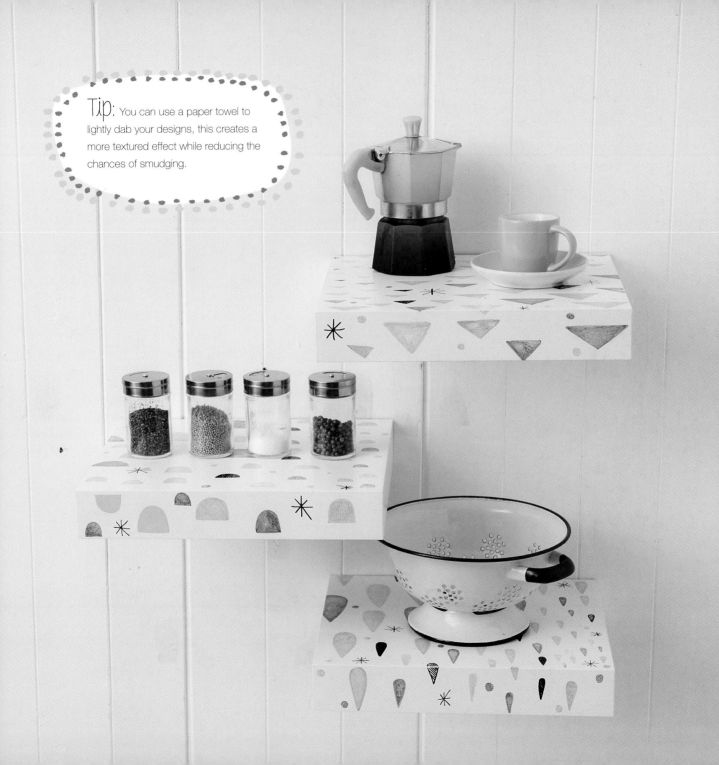

Tip: You can use a paper towel to lightly dab your designs, this creates a more textured effect while reducing the chances of smudging.

Woodland Lampshade

Transform a plain fabric lampshade into a personalized designer piece of home décor. This intricate pattern of birds, trees, flowers, and leaves is colored in varying shades of blue and red.

You will need:
- Fabric lampshade
- Pencil
- Paper
- Double-sided sticky tape
- Scissors
- Permanent markers in shades of blue and red

Skill level:

1 Place the lampshade on its side on a piece of white paper and use a pencil to trace along its bottom edge, starting at the point where it touches the paper. While rolling the lampshade in one direction, follow the curve of its edge with the pencil until you return to the starting point. When the bottom edge is complete, roll the lampshade back in the opposite direction and draw the top edge as you did the bottom. You will now have two curved lines for a cone-shaped lampshade, or two straight lines for a cylindrical lampshade.

2 Join the two lines with pencil and cut out the flat paper template. Using a pencil/permanent marker and the template, sketch your design or pattern onto the paper template.

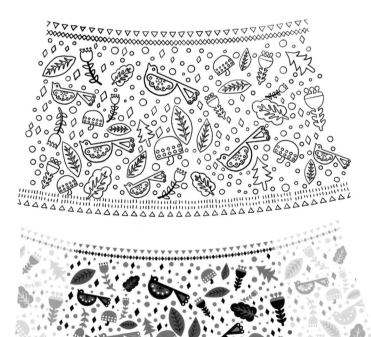

3 Using double-sided tape, stick the template onto the inside of the lampshade so it can be seen through the fabric and traced. Use a pencil to lightly trace the outline.

4 After the pencil tracing is finished, remove the lamp base and paper template, and use the permanent markers to color the design.

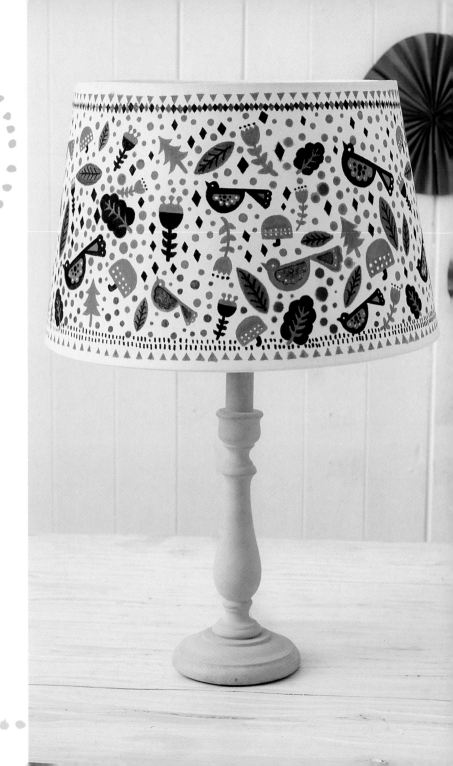

Flamingo Lampshade

Suggested Sharpie: permanent marker

Start by measuring the circumference of your lampshade and divide this by the number of flamingos that you want to feature on your lampshade. Mark these incremental measurements around the center of your shade. Draw a flamingo at each mark, beginning with the straight leg and body, and then adding the rest of each flamingo—the second leg, neck, head, and finally the beak and eye.

See the Flamingo Headphones project on page 40 for more ideas on decorating with flamingo motifs and the Woodland Lampshade on page 136 for another colorful lampshade project.

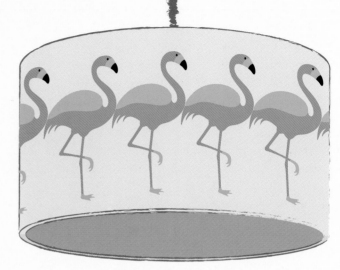

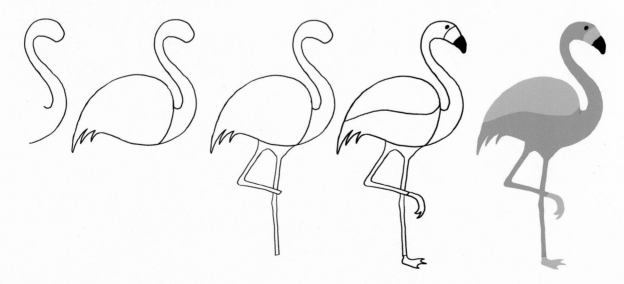

Patterned Stools

Suggested Sharpie: oil-based paint marker

These pattern designs for stools are simple and stunning. For each design consider where the stool will live in your house and choose colors that match your décor.

Stool 1: Choose three colors that complement one another and start by drawing a zigzag roughly across the center of the seat. Work outward from the first zigzag, alternating colors as you go, until the whole surface is covered.

Stool 2: Again, choose three colors that complement one another. Draw your first triangle roughly at the center of the seat, and then draw two more triangles emanating from each tip of your first triangle, alternating colors as you work. Build up the design, drawing two triangles from the tip of each subsequent triangle until the whole of the seat is covered. Finish off with a column of triangles up each leg of the stool.

Stool 3: Choose roughly five colors that complement one another and start at the center of the seat by drawing five leaves in a rough circle—if it helps you could imagine that the tips of the leaves create a pentagon shape. Continue to draw leaves in circles around the original leaves until you reach the edges of the seat, alternating colors as you work.

Why not try the Alpine Stool project on page 140 for an alternative design?

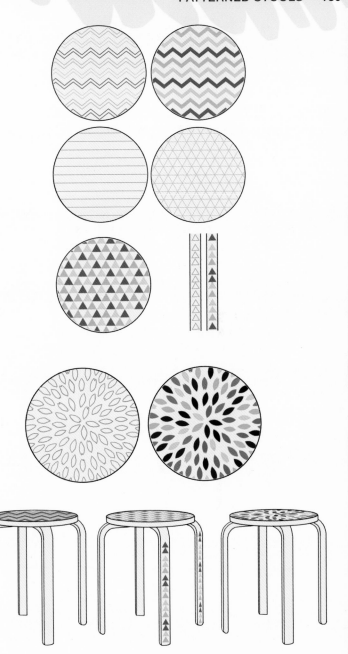

Alpine Stool

Decorate this handy stool with a quirky woodland pattern. Practical, functional, and fun, this stool will be a great addition to your kitchen.

You will need:
- Wooden stool
- Pencil
- Permanent markers in a variety of colors, including black
- Sealant

Skill level:

1 Wipe the surface of the stool with a wet cloth to ensure it's clean.

2 Using the templates provided as a guide, lightly sketch out the design on the stool. Use a pencil for this as it can easily be erased should you make an error.

3 Build up the design gradually using the different design elements; have fun with this stage. The design can be repetitive or you can add more of the elements you prefer and fewer of the others.

4 Now it's time to fill in the design elements with color—allow the ink to dry between motifs to avoid smudging.

5 Gradually fill all pencil marks with color and build up your design, allowing the ink to dry. Once the ink is completely dry add a layer of sealant to protect the design for greater durability.

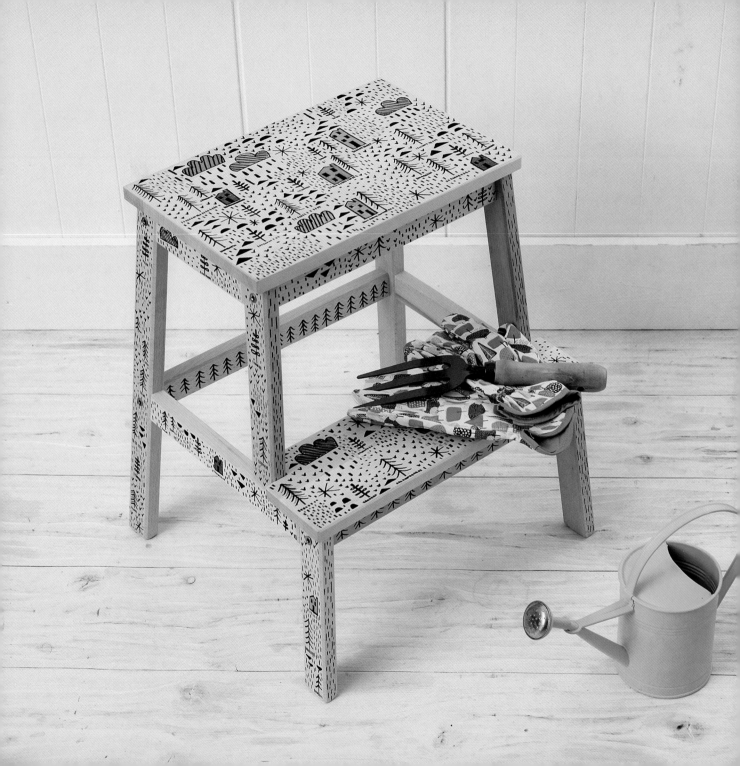

Rainy Day Table

Dress up a basic table with this whimsical bird pattern and you've got a stylish and fun new focal point for any room in your home.

You will need:
- Table
- Pencil
- Permanent markers in a variety of colors, including black
- Sealant (optional)

Skill level:

1 Wipe the surface of the table with a wet cloth to ensure it's clean.

2 Using the templates provided as a guide, lightly sketch out the design on the tabletop and legs. Use a pencil as this can easily be erased should you make an error.

3 Build up the design gradually using the different design elements; have fun with this stage. The design can be repetitive or you can add more of the elements you prefer and fewer of the others.

4 Now it's time to fill in the design elements with color—allow the ink to dry between motifs to avoid smudging.

5 Gradually fill all pencil marks with color, then allow the ink to dry completely. Add a layer of sealant for greater durability.

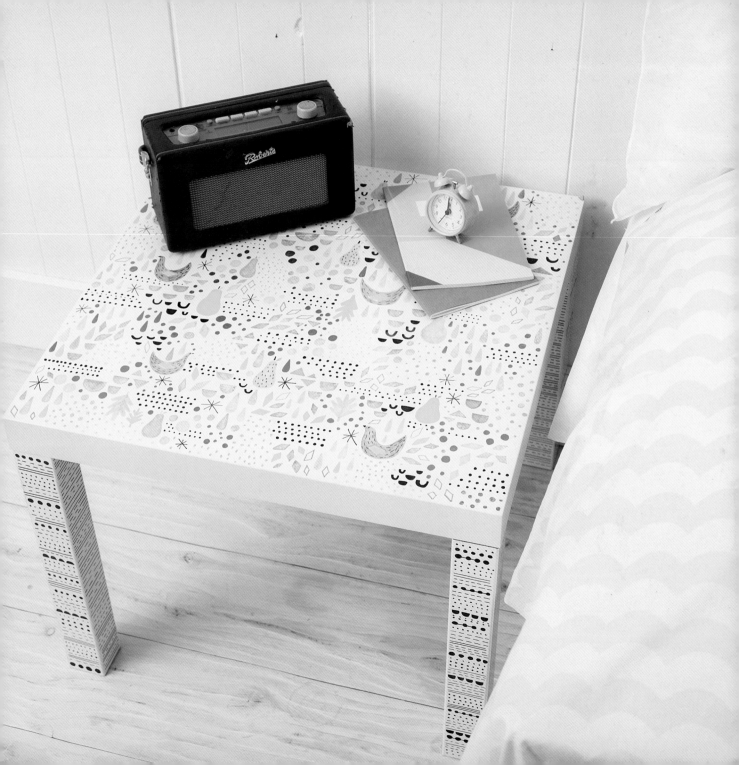

Acknowledgments & Index

Thank you to the great people at Quantum Books and William Morrow for all the support, and for making this book possible.

To my loving husband, thank you for being my soundboard and for always believing in me. And my sweet baby Otis, believe in your dreams and follow your passion.

Furthermore I would like to thank:

Hannah Meur (hannahmeur.co.uk) who provided the fantastic variation projects to this book.

Many thanks to these amazing illustrators for their contributions in designing and making the following projects featured in the book:

Kit Yan Chong
kekekaka.com
Woodland Lampshade (page 136)

Lucy Daniels
dippyegg.net
Fashion Floor Cushion (page 80)

Pui Lee
scouteditions.co.uk
Nature Skateboard (page 42), Cacti Tote Bag (page 108), and Cityscape Shoes (page 110)

Emma Margaret
emmamargaretillustration.co.uk
Summery Storage Box (page 56)

Ekaterina Trukhan
ekaterinatrukhan.com
Treetop Chair (page 132)

Nicola Youd
papermoonillustration.com
Whimsical Shelves (page 134), Alpine Stool (page 140), and Rainy Day Table (page 142)

Thanks to Lindsay Kaubi, Rachel Malig and Ann Barrett for their editorial work and index.